THE ART OF
CLOSE-UP
PHOTOGRAPHY

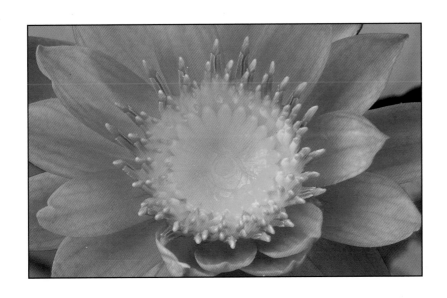

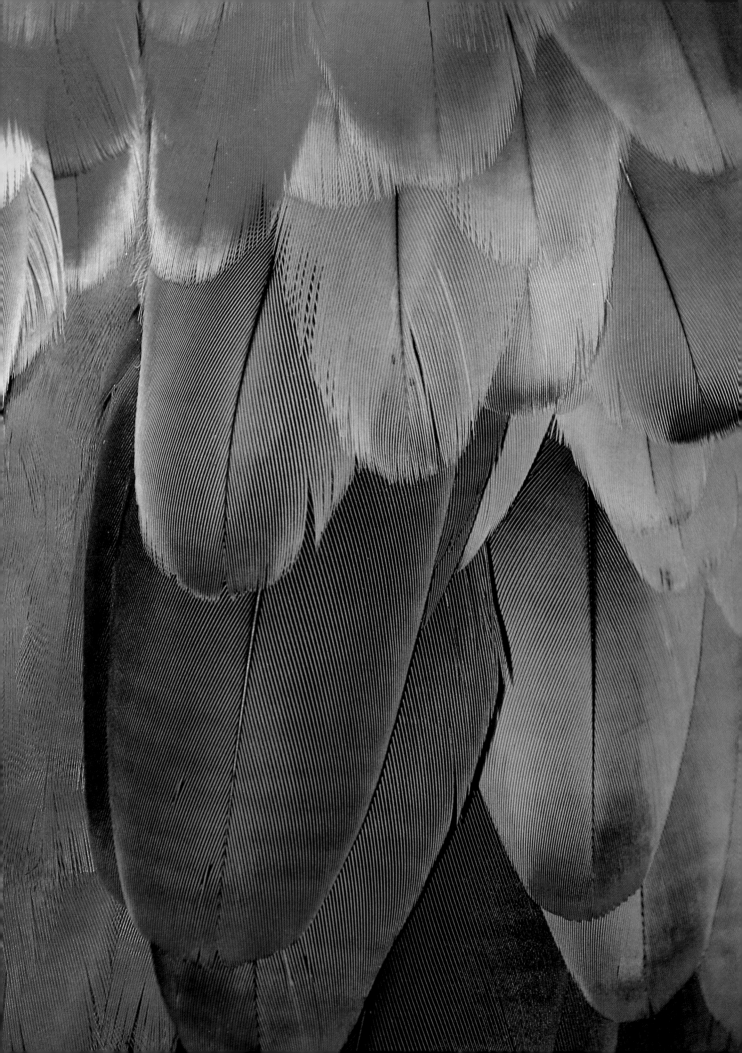

THE ART OF
CLOSE-UP
PHOTOGRAPHY

Joseph Meehan

NATURE PHOTOGRAPHY BY
Art Gingert

DESIGNER
Grant Bradford

FOUNTAIN PRESS

To Joseph James and Michael Joseph
With New Life Comes New Hopes for the Future

Published by
Fountain Press Limited
Fountain House
2 Gladstone Road
Kingston-upon-Thames
Surrey KT1 3HD

© Fountain Press 1994
ISBN 0 86343 356 1

Design & Layout
Grant Bradford

Typeset & Planning
Rex Carr

Reproduction
Erayscan - Singapore

Printing
Star Standard
Singapore

CONTENTS

INTRODUCTION

One of the most intriguing aspects of photography is its ability to capture, in a single photograph, those parts of our visual world that we do not ordinarily see. That is particularly true of close-up photography where the camera is brought very near to the subject magnifying its parts and structures beyond our usual vision. This different way of taking a picture invariably reveals a beauty that is both unique and fascinating even with the most mundane subjects. It is here that we discover miniature forms and structures that exist in exquisite detail rivaling anything in the world of normal proportions. Moving the camera close to the underside of a maple leaf, for example, discloses a complex of veins radiating across its surface that brings to mind our own vascular network. Pointing the lens down into the folds of a daffodil blossom records a range of subtle colours only hinted at by its diffused rusty-orange exterior as seen from a distance while small insects appear as fantastic inhabitants of another world instead of the tiny, often annoying intruders into our own.

Once we start moving in close and magnifying what can just barely be seen into something that fills the viewfinder of the camera, there is a realization of just how much escapes us because of the limitations of our vision and photographic perspective. Everything from the tiny details of an engraver's art in a section of a postage stamp or in the corner of the money we use everyday to the finely painted numbers on a old wrist watch become individual lessons of discovery about this world just beyond our perception. The prospect of such an unlimited supply of new subject matter and the concurrent potential opportunity to expand one's creative output can only bring excitement to the curious photographer.

Close-up photography remains outside the vision of most photographers because of the limitations of their equipment and because they do not think in terms of the close-up perspective as a photographic option. Thus, moving into this world requires three important changes from taking photographs at normal distances. They are; (1) the need to either modify conventional lenses to focus closer or to use specialised close-up equipment in order to magnify the size of the subject on film. (2) The need to develop a different way of looking at subjects and

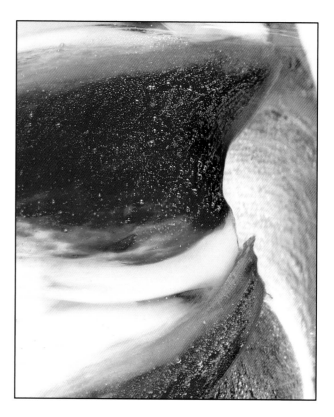

how they are composed on film and finally, (3) a large measure of patience to carry out the picture taking process with much more care and discipline than with subjects photographed at normal distances.

The main purpose of this book is to give the photographer all the essential information on equipment and picture taking techniques necessary to address these changes and make the transition into close-up photography as easy as possible. There are important new things to learn and, in some cases, a need to rethink some of the rules of normal proportion photography because of changes that occur when shooting close-up. While this is not a book for the neophyte, there has been an effort to explain the basics that underpin all of photography while concentrating on their role in close-up photography. This has been done because it is simply easier to build new knowledge within the context of the principles on which it is based.

Philosophically, the book follows the premise that the more a photographer knows about what he or

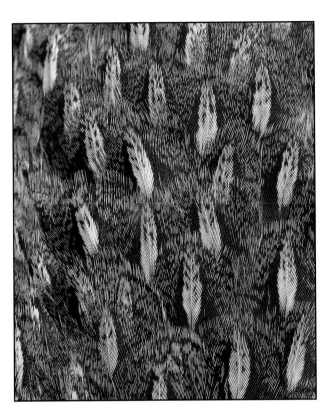

she is doing, the more likely they will succeed in what they want to do. Moreover, the greater the knowledge, the less they will have to depend on following a set technique and the more likely they will create their own techniques. Thus, a solid understanding of the techniques and equipment used in close-up work along with a sensitivity to key factors such as the quality of light and the photographic nature of the subject, invariably leads to a final image of higher quality and imaginative expression.

Organisationally, the book is divided into four chapters that cover the basic principles of close-up photography, the equipment needed as well as information on composition, lighting and exposure. Because close-up techniques are used in a number of different fields of photography we have built the content around the specific techniques common to these specialties on the premise that each has something to contribute to the general understanding of this subject. We also believe that many readers will be interested in adapting techniques from these

specialties to their own purposes and that most photographers are interested in working with a variety of subjects under diverse conditions.

Specifically, the book is organised into four parts. In the first chapter we will outline those key principles that form the basis of close-up photography and make this type of picture taking so different. We will also introduce the three major areas on which this book concentrates; namely, outdoor/nature photography, table top studio work and copy techniques. Chapter 2 then considers the key features that an SLR camera should have for various types of close-up work and why they are important. This is followed by a thorough review of the types of specialised close-up lenses available including how conventional lenses can be modified to focus closer and how all this equipment is used to compose pictures. Chapter 3 concentrates on the key points involved in the selection and use of tripods, films and filters pointing out why certain choices are better than others. Finally, Chapter 4 deals with the options involved in using available light and electronic flash in field work and the lighting options in a table top close-up studio as well as in various forms of copy work. The all important question of proper exposure is also covered along with specific methods of exposure.

Throughout the book, general guidelines and recommendations concerning close-up methods and equipment are presented in a highlight format as well as important picture taking tips within the text to help solve those typical problems encountered in the field, studio and on the copy stand.

A Note on Technical Information

The Art of Close-Up Photographer assumes that the reader is familiar with the basic principles of photography such as calculating proper exposures, controlling depth of field and something of the photographic characteristics of light. Any additional technical points critical to close up photographers are covered within the text of the book. In addition, an Appendix containing further explanations and information about key basic principles has also been provided. The reader is therefore, referred to the Appendix when there is a need for further information.

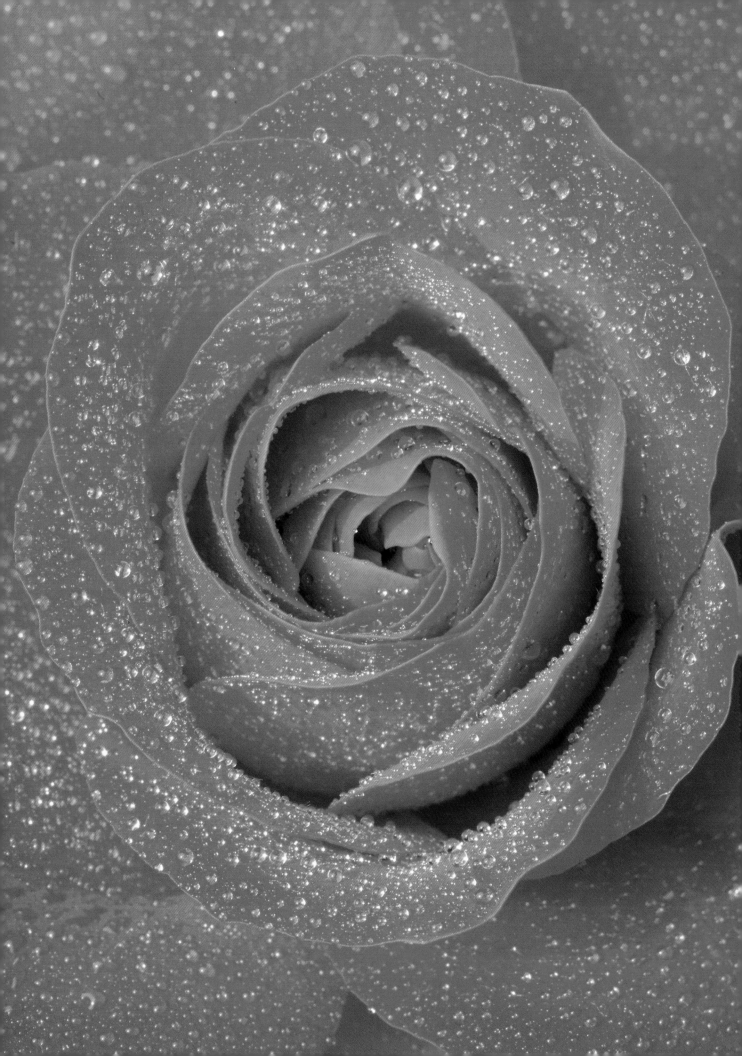

AN INTRODUCTION TO CLOSE-UP PHOTOGRAPHY

Each area of photography has its own language and concerns that relate to those aspects that are both peculiar to and of greatest concern for anyone working in that area. Close-up photography is no different. Thus, if we had to isolate the one key principle on which this whole field is based it would be not so much how close a lens can get to the subject, but how much that subject will be magnified on film. After all, it is only through enlargement of the subject that the lens will be able to reveal that world beyond our normal vision that we are after. As magnification increases, however, important new conditions and concerns are brought into effect, requiring the photographer's attention in ways that are different than in normal distance photography. So while it is the higher on-film subject magnification that gives close-up photography its unique visual character, the process of obtaining those magnifications also sets this area apart technically from other types of photography.

This is also a field of great diversity, both in terms of subject matter and in equipment designs. As we will see throughout this book, close-up photographs can be taken in any number of ways with a wide range of lenses and accessories. In fact, it can sometimes be confusing when trying to sort out the many choices in hardware and picture-taking techniques that are available. Since the critical characteristic of close-up photography is the on film magnification of the subject, one of the best ways of approaching these many alternatives is to first have a general idea of how big you want the subject to appear on film.

Magnification Ratios; the Basic Language of Close-Up Photography

The term 'Magnification Ratio' represents the basic language used by close-up photographers when talking about their diverse field. It is defined as 'the ratio between the size of the subject on film and its actual size' as summarised in the following simple formula;

$$\frac{\text{MAGNIFICATION}}{\text{RATIO}} = \frac{\text{NEGATIVE SIZE}}{\text{AREA OF COVERAGE}}$$
$$\text{(i.e. size of subject)}$$

For example, a 1:10 ratio means that the image size of the subject on the film is one tenth its real size, while a 1:2 ratio indicates that the camera has recorded a one-half life-size image. There are a number of ways of expressing this ratio; for example the 1:2 half life size can also be indicated by the notation $\frac{1}{2}$x or 0.5x. We will use the X:Y ratio format throughout the book in which:

X = image size on film

Y = the actual size of the object.

So again, a 1:10 notation means that the real object is ten times larger then what has been recorded on film while a 1:2 notation means that the on film magnification is now much greater with the actual object only twice as large as its on film image.

Most close-up photographers use magnification ratios as a common denominator when working with different equipment and techniques. This provides a universal frame of reference that can be visualised when talking about various equipment set ups such as the focal length of the lens being used and its 'working distance' or how close it is when focused on the subject. A key reference point in the magnification ratio concept is the 1:1 ratio or 'life size' magnification which represents what is technically known as 'macrophotography', or simply 'macro close-ups'. This is a situation in which the size of the subject on film and the actual size of the subject are exactly the same. For example, if the negative of a postage stamp shot at a 1:1 ratio were placed directly on top of the actual stamp, they would match each other in perfect registration.

The concept of magnification ratio also sets realistic limits on what can be photographed since it indicates in advance, just how large the subject will appear on film. Thus, in the case of a 35mm frame exposed at a 1:1 life size ratio, the largest subject or part thereof that can be photographed is limited to 24 x 36mm or approximately 1 x 1.5 inches. For medium format cameras, the maximum subject size for a 1:1 magnification would be larger by as much as two to

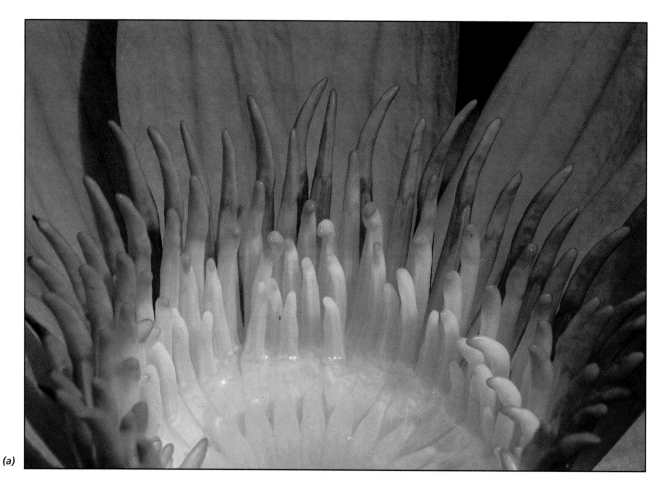

(a)

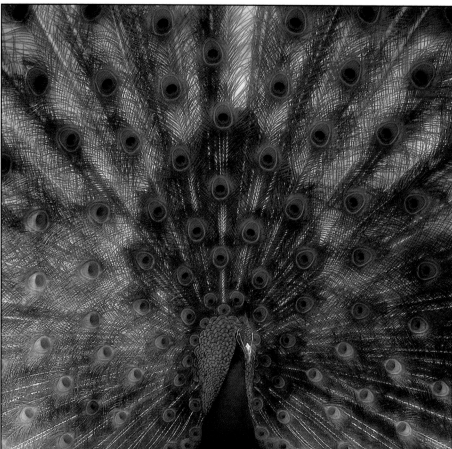

(b)

Subject matter from the natural world probably represents the largest single area for the practice of close-up photography as, for example, in (a) Art Gingert's shot of a Tropical Water Lily, or (b) the plumage of a peacock by the author. But there are also endless opportunities with man-made objects as in (c) a bullet holed sign from a ghost town in the American West or (d) a rusting name plate from an old boiler, both by Joseph Meehan. There are also the 'arranged compositions' of a still life to reflect a sense of a place, a memory or a person as in (e) Joseph DeGeorge's table top shot in natural light overleaf.

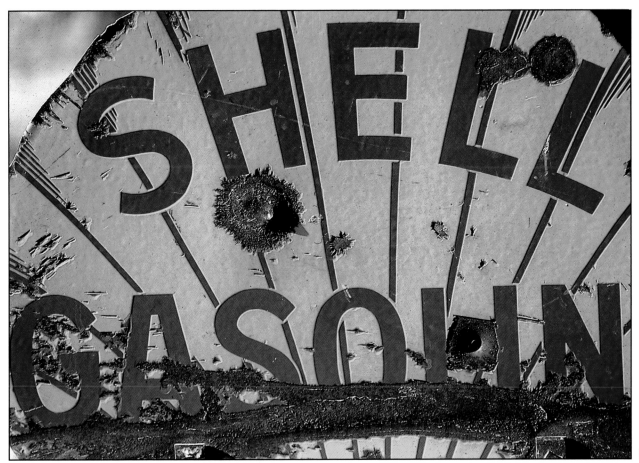

(c)

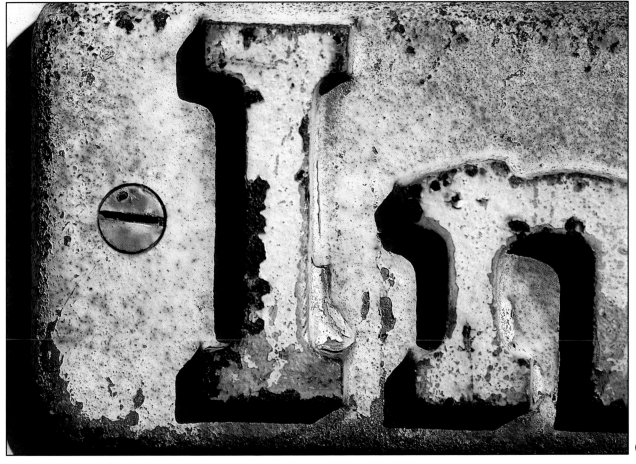

(d)

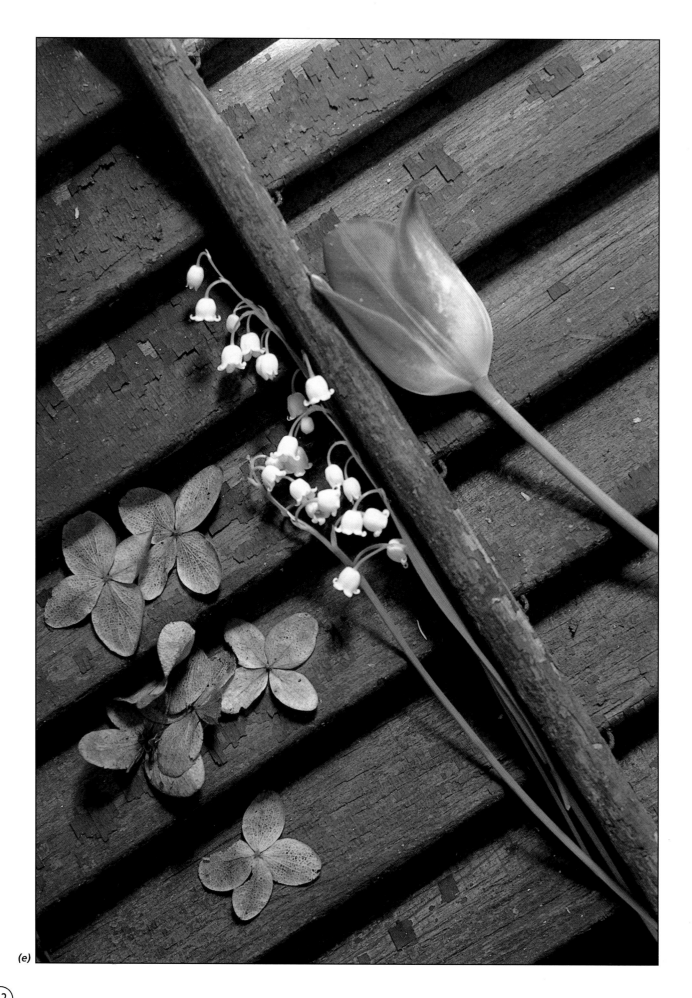

(e)

12

four times in direct proportion to the size of the negative.

A lens that is capable of recording a 1:1 life sized image, regardless of focal length or focusing distance, is functioning as a macro lens. For example, a typical medium telephoto such as a 105mm f/2.5 lens equipped with an extension tube (which allows it to focus closer) can focus to 16 inches from the subject to yield an on film 1:1 image. On the other hand, a particular brand of macro lens, such as a 60mm f/2.8 micro Nikkor lens made by Nikon will record a 1:1 ratio at 9 inches without the use of extension tubes. From this example we also see that if the magnification ratio of the subject recorded on film is the same for different lenses, then as the focal length increases, the closest focus distances between subject and camera also increases. This working distance is usually measured from the point where the photographer focuses on the subject (principle point of focus) to the front of the lens. Working distance figures may vary significantly between lenses of the same focal length because of different optical designs. For example, a few lenses used in close-up work have 'IF' or 'Internal Focus' mechanisms seen in many of the newer long telephoto lenses in 35mm photography. In this case, the internal lens elements move as opposed to the more common design in which the whole lens barrel moves closer to the subject when it is 'racked out' for a close-up.

Categories of Close-Up Photography and Important Terminology

As a generalisation, close-up work begins with a 1:10 magnification ratio and extends to an extreme of between 3:1 and 4:1 where the subject's on-film size is three or four times that of its actual dimensions. It is certainly possible to further increase the magnification ration beyond 4:1 and some photographers do, but the vast majority of work done in this specialty is in the 1:10 to 4:1 range. While the 1:1 ratio represents a convenient center reference point of macro photography, that designation and the term 'macro lens' has been used rather loosely. Particular offenders in this regard are the so-called 'macro zooms.' Even many single focal length lenses specifically designed for close-up work only produce a 1:2 ratio but usually come equipped with an accessory 'close-up extension tube.' When this device is mounted between the lens and the camera, these lenses then produce a 1:1 'true macro' image. There is also the term 'micro lens' used specifically by Nikon for their close focusing lenses which is just another name for macro lens but is a bit confusing since this seems to imply magnifications in the range of a microscope.

As was pointed out, magnification ratios higher then 4:1 are possible with photographic equipment with even higher magnification ratios obtainable by using a microscope with camera attached. In the latter case, the magnification ratios are measured by the power of the microscope and extend well beyond 4:1. Here, the camera body is attached to the ocular of the microscope (which itself is part of a very solid stand) and its powerful optics become the lens. In fact, one of the reasons photographers do not commonly go beyond a 2:1 or 4:1 ratio is that the photographic equipment necessary to work at greater than 4:1 is difficult to work with, especially because of the extremely small working distance which makes it hard to maneuver into position for the shot. The advantage of having a ridged design of a microscope for the viewing/picture taking mechanism and a specimen stage with provisions for moving the subject field around just a few millimeters by the use of a 'mechanical stage,' certainly represents an obvious advantage.

One of the most important advantages of having some idea of what different magnification ratios will produce on film is that the photographer is able to do some pre-visualization about what portion of the subject will be framed and anticipate the shooting conditions that will be operating when taking the picture. For example, with the 1:1 reference point it is easy to conceive of exactly how much of the viewing area in the camera's finder will be taken up by the subject since the exact field area is known; that is, 24 x 36mm or 1 x 1.5 inches. This, in turn, will give a rough feeling for how much space will be left for the background, foreground or other nearby subjects in the composition. Thus, a small flower or stamp measuring about 1 inch horizontally will take up approximately two thirds of the 1.5 inch horizontal portion of a single frame of 35mm film leaving the rest of the space for composing a border to perhaps frame the subject. Just carrying around a blank 35mm slide mount and using it to roughly frame subject matter is a very effective way of developing an appreciation of the 1:1 ratio.

Magnification ratios will also determine which specific equipment should be used as well as making the photographer aware of the various changes in shooting conditions brought on by working at each magnification. There is, in fact, a simple principle operating here; the higher the magnification ratio, the more care has to be taken with the actual mechanics of taking the picture. The reason for this is that the rules controlling exposure, depth of field and the detrimental effects of camera shake or subject movement that apply in normal distance photography change significantly in close-up work. Hence, equipment choices for lower magnification ratios for a particular setup selected for work indoors may not prove practical for higher magnifications or in a field work environment.

In order to make it easier to organise the changes that become more and more critical as the

(b)

(c)

The greater the size of the subject recorded on film, the higher the magnification ratio and this measurement has been used in this book to establish three close-up categories. (1) 'Moderate Close-Up' range with a maximum ratio one-fifth (1:5) of actual size to about one-tenth (1:10) as in (a) opposite a moderate close-up of a Great Horned Owl by Art Gingert using a 100mm macro lens. (2) 'Macro Close-Up' between one-quarter life size (1:4) down to (1:1) as in (b) a life size shot of a postage stamp by the author. (3) 'Extreme Close-Up,' beginning at twice the normal size (2:1) or more where details are revealed often outside our normal vision as in (c) the inside wall of an Oriental Poppy by Art Gingert.

magnification ratio becomes larger, this book divides all close-up photography into three categories with each of these three divisions identified with certain types of subject matter and equipment. In addition, each division is identified with a range of usable depth of field, a specific amount of exposure adjustment and the minimum shutter speeds that have to be used with certain subjects.

(1) Moderate Close-ups; extending from 1:10 to 1:5.

Approximate subject sizes: from $1/2$ to 1 foot square.
Typical depth of field: from about $5^1/2$ inches for f/11 at 1:10 to about 1 inch at f/22.

Examples include full portraits of plants including larger leaves and flowers, several small toy automobiles or a group of stamps or coins, one or two samples of paper money, as well as details of very large objects such a car's bright work or stained glass panels. This is the range for such studio small-product shots as perfume bottles and larger jewelry pieces and outfits as well as the vast majority of copy work on a copy stand.

(2) Macro Range Close-Ups; extending from 1:4 to 1:1.

Approximate subject sizes: from 6 to 1 or 2 inches.
Typical depth of field: about 0.09 inches.
Examples include tight compositions of small wildflowers, single postage stamps and coins, full views of small products such as earrings or bolts and smaller insects such as honey bees, as well as most 35mm slide duplication work.

(3) Extreme Close-Ups; extending from 2:1 to 4:1 or more.

Approximate subject sizes: less than 1 inch.
Typical depth of field: 0.010 inches and less.
Examples include parts or sections of subjects such as plant structures or the eye of an insect and extreme details of postal stamps and coins, as well as a portion of a 35mm slide for enlargement.

With these general divisions in mind, we can now consider those changes relating to exposure, depth of field and shutter speed that occur when shooting close-up. In the next chapter, we will use these categories again when considering choices in close focusing equipment as well as when discussing various points concerning exposure, lighting and composition in the last two chapters of the book.

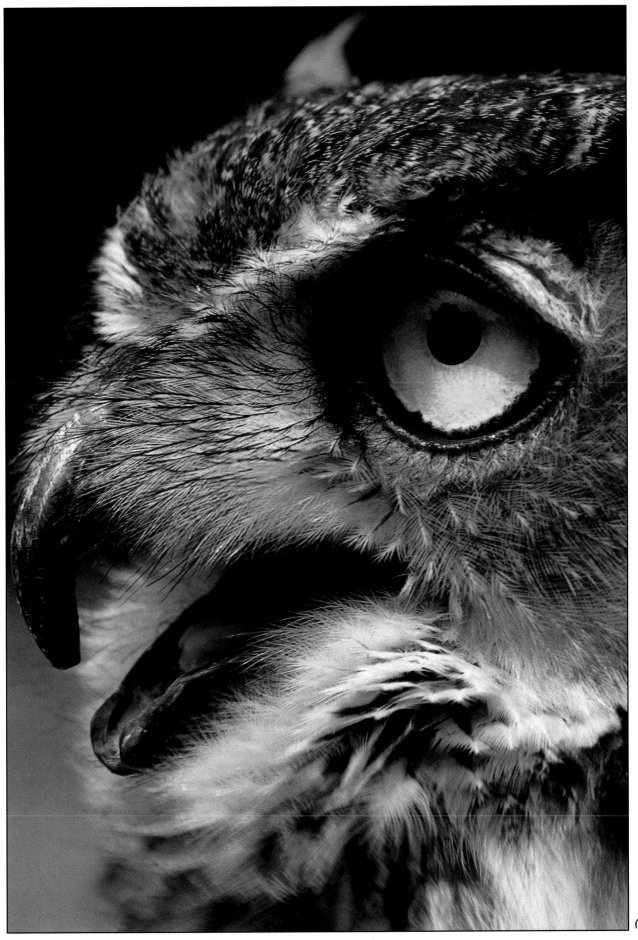

(a)

How Close-up Photography Changes the Rules

One of the first things a photographer notices when working at close-up magnification ratios is that any movement on the part of the subject or the camera during the exposure has a detrimental effect on image sharpness. This effect is far in excess of what would be expected in normal distance photography. For example, to avoid the blurring effect of 'camera shake,' there is a general rule in photography that 'the minimum handheld shutter speed an average photographer should use to avoid the effects of camera shake can be determined by converting the reciprocal of the lens' focal length to the next highest shutter speed.' In other words, a 50mm lens requires a minimum speed of $^1/_{60}$ second, a 100mm lens $^1/_{125}$ second and a 200mm lens $^1/_{250}$ second. While this rule may work well for distant objects, it cannot be applied in a practical way to close-up work. Here is why.

The focal length of a lens is determined by measuring the distance between the point where the image is focused with the lens set at infinity and a specific optical point in the lens called the 'rear principle' or 'rear nodal' point. For all practical purposes, this is the distance between where the film is in the camera (the film plane) and the rear of the lens and is traditionally expressed in millimeters. For example, a 50mm lens indicates that there is a space of 50mm between the lens and the film plane.

The key here, is the requirement that the lens be set at infinity focus. Consequently, when focusing closer to the subject there is, effectively, a change in the focal length. That is, a picture taken by a 50mm lens of a specific subject such as a flower at ten feet shows twice as much area of the flower as a 100mm lens from the same distance. But if the 50mm lens were moved to five feet it would now produce the same picture as the 100mm lens at ten feet. In practical terms, halving the focusing distance effectively doubles the focal length relative to the subject. In other words, the actual focal length assigned to a lens is based on a calculation done with the lens set at infinity but shorter subject to film distances cause the on film image to be magnified beyond that achieved at infinity focus. Imagine then, what the result of a 50mm lens focused down to a few inches. It amounts to working with the magnification power of a very long telephoto lens. Among other things, that means just the slightest movement of the camera will be magnified to the point of causing the picture to appear soft or even blurred.

The results of camera shake can often be very subtle and many photographers attribute its effects to what they think is the poor quality of a lens or film. To avoid this, accomplished close-up photographers work with their cameras on a solid tripod virtually all the time or rely either on action-freezing high shutter speeds or the short exposure duration times of electronic flash. Moreover, they are also concerned with the possible interference of 'mirror slap' as the SLR mirror moves up and out of the way during the picture taking process. To avoid any possible interference from this action many professionals prefer to use a camera that has a mirror lock-up feature or a self-timer in which the mirror is raised a few seconds before the picture is actually taken, allowing any internal vibrations to dissipate.

Keep in mind, however, that in this example, lenses of different focal lengths at different positions from the subject will change the perspective and therefore the way the background will appear. Thus, in the illustrations showing the one-way signs, notice how the size of the sign itself is about the same, but the appearance of the background has changed radically due to the change in perspective of different focal length lenses held at different distances to the subject.

Another major consideration when working with magnified images is the effect that closer focusing has on depth of field. Depth of field is that area in front of and behind the point of focus that is considered to be acceptably sharp. The amount of depth of field any individual lens can produce is controlled by the aperture selected. Large aperture openings such as f/1.4 or f/2.0 produce a shallow depth of field while small openings such as f/16 or f/22 yield much larger ranges of focus. As a lens is stopped down (that is, the aperture made smaller), the depth of field increases by a factor of 1.4x for each stop.

There is the popular but false belief that one third of the total depth of field falls in front of the principle point of focus on the subject with the remaining two thirds falling behind the subject. This is the so-called 'one third/two third rule' but this is not always true or even the case frequently enough to serve as a guideline much less a rule. It is one of those enduring photographic myths that can mislead a close-up photographer who always has to be concerned with depth of field in literally every shot. For example, a 105mm lens focused at two feet will produce virtually the same depth of field area in front of and behind the point of focus across its entire f/stop range. Moreover, the depth of field in most close-ups shows an equal amount in front of and behind the subjects especially in the macro and extreme categories.

Focusing closer to the subject has the effect of reducing the total amount of depth of field in the same way that using a longer focal length results in less depth of field. This makes sense since, as just pointed out, the effective focal length is increasing as the camera moves closer to the subject. It also follows, that if the on-film image size (that is, the magnification ratio) is the same from different focal lengths the image will show the same amount of depth of field. Thus, in this context of close-up photography, it is wrong to assume that longer

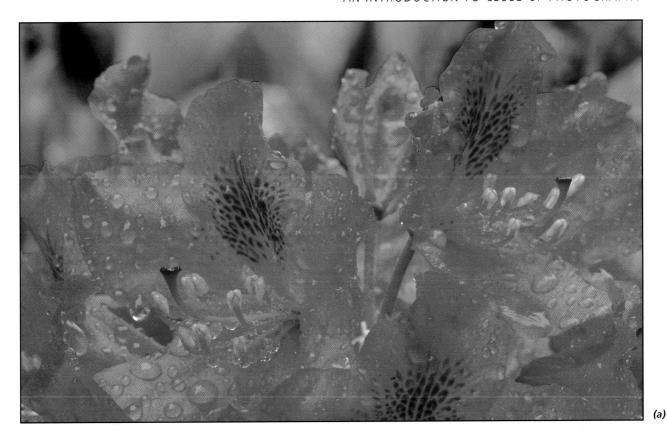

(a)

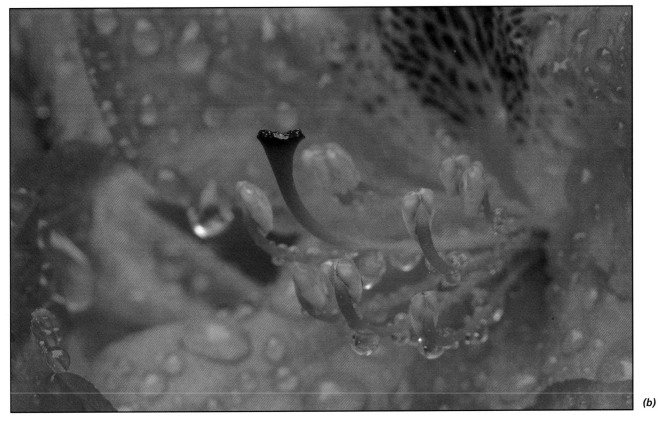

(b)

Moving closer to a subject decreases the amount of depth of field as seen in (a) and (b) where Art Gingert moved in on a Rhododendron blossom with a 100mm macro lens. The same effect would have been achieved by using a longer focal length lens from the same position (see Figure 1, overleaf).

telephoto focal lengths have less depth of field than wide angle short focal length lenses. As long as the magnification ratio achieved by different lenses is the same, the depth of field will effectively be the same regardless of focal length. For example, in figure 1, a 105mm lens at a working distance of 48 inches has the same effective focal length as a lens twice its size (210mm) set at twice the distance or 96 inches. As you can see from the chart, the depth of field is exactly the same for each of the three aperture settings given for a 105mm lens at 48 inches and a 210mm lens at 96 inches; that is, 1.2 inches at f/4, 2.3 inches at f/8 and 4.7 inches at f/16.

As magnification ratios increase, the area of usable depth of field decreases significantly, making it logical to assume that a photographer should shoot at the smallest aperture. Unfortunately, this is not always a good practice. Lenses represent a series of optical compromises in which the flaws in a particular design or in the makeup of the glass itself are played against one another. Result: there is no such thing as a perfect lens but rather the result of many compromises. In fact, each f/stop will record the image to a different degree of sharpness and contrast reflecting the many compromises that have to be made when a lens is designed. Generally, the f/stops at the extreme of the aperture scale, as in the maximum and minimum aperture settings, are the poorest performers in terms of sharpness and contrast. It is good procedure to know just how much image quality is being lost at these apertures, particularly at the minimum aperture opening for close-up work by shooting some frames at the middle to the smallest f/stops and compare the image quality of the results.

Key Factors in Selecting a Close-Up System

Before thinking about which particular lens to select for doing close-up work, first consider the degree of on-film magnification desired. That is, which of the three magnification ratio categories do you plan to work in? This decision will, of course, depend greatly on the chosen subject but also on your intent. Furthermore, what are your purposes? To explore the overall shape of the subject from a close-up perspective or to move in and show some of its individual structures? Having at least a general idea of what you are after is very helpful at the outset so you can make the specific choices in equipment that are discussed in the next chapter.

As you think about this, consider the second most important factor, which is: how much working distance is needed to work comfortably with that subject? This is of special concern when working with live subjects, such as insects which have a certain area called the 'approach distance' or 'circle of fear' around them roughly equivalent to our own personal space, in which they will not tolerate intrusion. With non-moving subjects, it might be a matter of being blocked from getting close to your subject as when photographing bird nests in a dense shrub. Then, there is the danger of getting so close at a particular magnification ratio that the lens, camera and even the photographer interferes with the light. Needless to say, magnification ratio in conjunction with working distance are very critical factors when selecting equipment.

As a general rule, you can expect to use aperture settings of between f/8 and f/22 for most

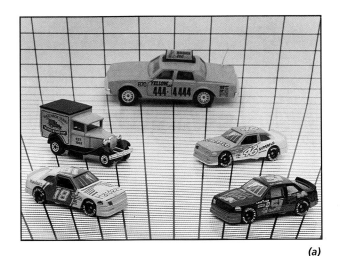

(a)

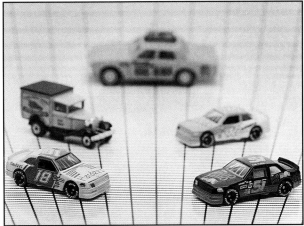

(b)

Once a lens and position has been selected, the loss of depth of field comes from changing the aperture as in (a) at f/16 to f/4.0 in (b).

Photographed on a table top studio by Joseph Meehan, 200mm macro lens. (Collector cars supplied by Joseph Cortese).

close-up pictures in order to produce as much depth of field as possible. It follows then that, fast lenses are really unnecessary in close-up work; rather a better choice is one with smaller apertures such as f/22 and f/32. Although lenses perform best at the middle apertures there will be times when depth of field in the composition requires you to stop down completely. Without the option to go to these very small openings, the picture is lost, which is a far worse option than being able to produce and image that is not as sharp as might be possible at a middle aperture. Keep in mind also, that depth of field is a 'manageable concept' at moderate and macro close-up magnifications in that you can significantly alter it by changing apertures but in the extreme range, the depth of field is minimal across the whole aperture range.

Because of the degrading effects on image sharpness from even the slightest movements of a subject, you will have to use shutter speeds of at least 1/60 second and higher with even the slightest subject motion as, for example, when shooting a moderate close-up of a flower when a gentle breeze is present. Longer shutter speed exposures are only feasible when there is no subject movement at all and that very often means a test of your patience by waiting long periods of time for a breeze to stop. Consequently, a sturdy, easy-to-use tripod is an absolute necessity in close-up photography and you should expect to use one for virtually every image in which available light is used. Furthermore, decisions about which types of equipment are to be used with various subjects are predicated largely on how well this equipment will work when used on a tripod.

There is one other change in normal picture-taking procedures that needs to be considered and that is the fact that exposure readings taken at normal focusing distances cannot be used within the three close-up categories. In point of fact, the accuracy of the f/stops on a lens are based on the lens focused at infinity. When a lens is focused closer, much closer to a subject, there is a need to compensate for a loss of light. What causes this loss of light? The same factors that make a flashlight (or any light) shine very brightly in the first few feet but dim significantly as the beam of the light is directed further and further away. That is, the fact that the light has to travel a greater distance.

In the case of a close focusing lens, light has to travel from where it physically leaves the glass of the last lens element at the back of the lens over a distance to strike the film. When a lens is focused closer and closer to the subject, this rear portion of the lens pulls further and further away from the film so the light can be focused. This can be seen by just watching the rear elements move up inside (particularly with macro lenses) as the focusing collar is rotated to its closest focus setting. Also, one of the chief methods of making a lens focus closer is to install some sort of extension device between the lens and the camera body as in a bellows or rigid extension tube. In both of these situations the lens-to-film distance is increasing, resulting in a decrease in the total amount of illumination reaching the film. Anyone who has worked in a darkroom has seen this loss in intensity of light caused by an increase in distance when an enlarger is raised to make a larger print. The result is always the need to either increase the exposure time or open up the aperture.

The exact amount of light loss due to increases in distance is determined by the 'Inverse Square Law of

Light' which states that 'the intensity of the light decreases in an inverse proportion to the square of the total distance.' For example, if a 100mm macro lens is focused at infinity in bright sunlight, the correct exposure would be f/16 at $^1/_{125}$ second with an ISO 125 film. If that lens were then focused to its closest focusing distance of about 13 inches, the new exposure would be f/8 at $^1/_{60}$ second. The Inverse Square Law is an operating principle in all of photography and to see a chart of its effect simply look at the distance dial of any on-camera flash. Notice how as the f/stop settings change, the distance changes inversely.

In normal-distance photography, typically between infinity to about two feet, changes in the exposure caused by light loss are minimal, amounting to less than one half of a stop. Once the focus point drops below about two feet, there is a need to correct for the greater amounts of light loss. Since we stated that the key to understanding and thinking in close-up terms is to use the concept of magnification ratio (M), a simple formula based on that measurement will illustrate how much loss in light intensity can be expected;

$$\text{Exposure Factor} = (M + 1)^2$$

The Exposure Factor is the amount the exposure must be increased. Thus, if the figure works out to be 2, or more precisely, 2x then the exposure must be doubled. As we will see in greater detail in Chapter 4 in the section on exposure, doubling the exposure is the equivalent of either opening up one stop or slowing down by one shutter speed. Therefore, knowing what magnification ratio is being used makes it possible to quickly calculate how much light will be lost and exactly what increase in exposure is necessary. Thus, if we are working with a 1:2 ratio (half life size), the calculations would be $(0.5 + 1)^2$ which works out to be an exposure ratio of just over 2x. In this case, the exposure must be increased by the equivalent of one stop in all shots as long as the magnification ratio remains at or very near one-half life size.

Fortunately, the built-in camera meters in most SLR cameras compensate very accurately for the changes in light brought on by close-up work so that the light loss does not present any real problem for the SLR photographer. In fact, exposure compensation is made so easy by the built-in meter design of a typical SLR camera that the user doesn't have to know any of the mathematical relationships just presented. The one reality that will have to be dealt with, however, is the effect this loss of light (which can be as much as three stops when working at the extremes like a 2:1 ratio) will have in requiring the use of slower and slower shutter speeds.

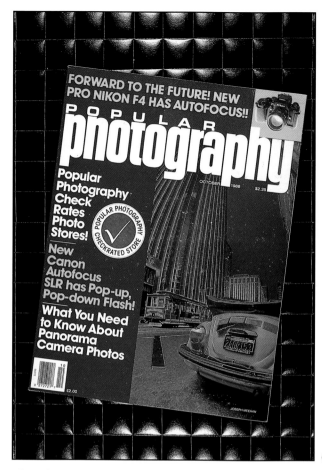

(b)

The Close-Up Photographer's Dilemma

These shooting conditions of decreasing depth of field, the loss of light as a result of focusing closer and the frequent need for motion-freezing shutter speeds because of subject movement present a certain dilemma for the close-up photographer, especially under field conditions. On the one hand, concerns about subject movement caused by even a gentle breeze necessitate the use of higher shutter speeds. At the same time, the aperture must be stopped down to at least the middle f/stops for any kind of reasonable depth of field. Yet, getting closer and closer results in a loss of light reaching the film which must be made up for by either slower shutter speeds or wider apertures.

All this is further compounded by the fact that the best close-up photographs are made with fine grain, slow films with typical ISO ratings of 25 to 64. Photographers like to use such films because they do such a superb job of capturing the fine detail that is characteristic of the best of this type of photography. In bright sunlight, the correct exposure for an ISO 25-50 film is between f/8 and f/5.6 at $^1/_{125}$ second. In open shade, that figure drops by 1 stop and in deep shade by as much as 2 to 3 stops more. In order to get a reasonable depth of field the photographer will have to shoot with f/11 or f/16 apertures and that means shooting at shutter speeds of $^1/_8$ or $^1/_4$ second. Now subtract another stop of

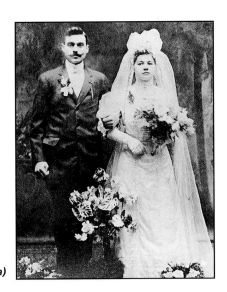

(a)

(c)

(d)

Examples of Moderate Close up Photography; This is the most widely used range of close-up photography with the greatest variety of subject matter. Common examples include almost all copy work done on a copy stand (a) a monochrome copy of a turn of the century wedding photo or (b) a documentation shot of one of the author's cover photos. Most small product photography employs moderate close-up techniques in a table top setting as in (c) and (d). Other typical applications are when a procedure has to be broken down into individual parts with close-ups used to show a step by step procedure as in (e) where moderate close-ups of a person's hands were shot for an instructional brochure on the methods used in 'horse driving' (all photos by Joseph Meehan).

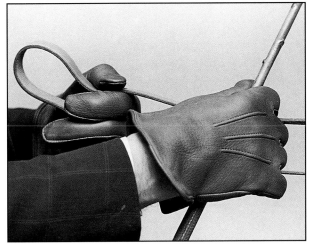

(e)

(f)

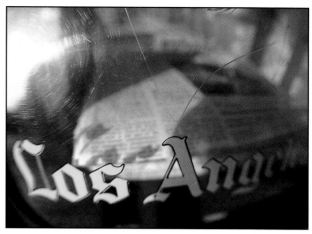

(g)

The moderate close-up is also the range in which wide angle lenses can be used very close to a subject to capture parts of a background as in (f) in which the background is kept in focus at f/16 or thrown out of focus as in (g) at f/2.8.
(both photos by Joseph Meehan using a 16mm, full-frame fish eye lens).

light due to close-focusing and the shutter speed slows down by another setting. This is why one of the most important qualities a successful field photographer must have is the patience to wait for minutes, or perhaps even an hour or so for that one moment when the breeze stops and the subject is perfectly still and can be captured on film at a slower shutter speed.

Applications of Close-Up Photography

The principles of close-up photography covered in these opening pages are used in a number of specialised fields including nature photography, small-product studio work and copy/duplication methods such as using a slide duplicator or working on a copy stand. The subject matter for each of these specialties varies but the basic principle remains the same; to use equipment and procedures that enlarge the size of the subject on film beyond what a conventional lens can deliver. The techniques of these specialties have much to offer a photographer who is interested in exploring the world of miniature subject matter so they are being introduced here and their methods and equipment referred to throughout the book.

Nature/outdoor photography

Perhaps the most popular form of close-up photography is practiced out in the field by photographers who are interested in recording the intricacies and often fantastic beauty of the natural world as well as man-made objects. Typical subject matter for the nature photographer includes flowers, insects, reptiles and small mammals as well as the inorganic structures of earth, rock and water. Besides the peculiarities of their subject matter, nature photographers stand apart from all other close-up photographers because they have to deal often with moving subjects as well as the vicissitudes of weather and sunlight, neither of which are under their direct control.

As a group, they have to be the most patient and accepting of photographers because of the need to first find their subject and then wait for just the right conditions under which to shoot. Specifically, the most influential factors are the location of the subject and the quality of the light as well as the presence of wind. To some degree, the quality of the light can be dealt with through the use of reflectors and diffusers which, as we will see in Chapter 4, can significantly change the appearance of the subject. On the plus side, there is often a situation in which available light is truly spectacular and arguably 'not reproducible'

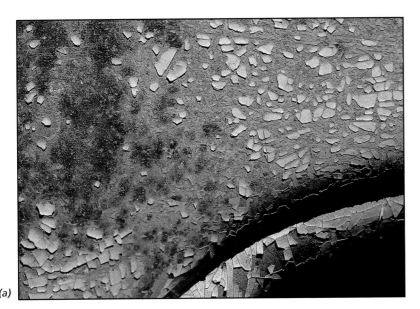

(a)

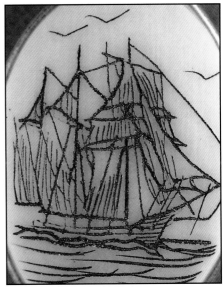

(b)

Examples of Macro Close-up Photography; Using magnification ratios of 2:1 down to 1:1 (life-size) will reveal details about the subject that are only hinted at by a photograph taken at normal distances. For example, peeling paint on a derelict car at 2:1 magnification with a 60mm macro lens in (a), or the hidden art of the scrimshaw carver at approximately 1:1 magnification (b) (both photos by Joseph Meehan).

even under studio conditions. Control over location and wind is, however, another matter.

Besides the patience necessary to find the subject and then arrange just the right position for a shot, it is the 'breeze time' that really tries the patience of the field photographer as the minutes tick away and the light changes. There are a few things that can be done such as building a temporary blockade for the wind, but in the end, it is the perseverance of the photographer that is the greatest asset with the reward being a beautiful image that can be obtained in no other way. As one well-known nature photographer lamented: 'If I was paid by the hour for waiting for a breeze to stop long enough for a slow shutter speed exposure, I would be a rich man today!'

It is probably not an understatement to say that we can never know the full extent of the perseverance nature photographers need to apply when photographing a subject under less than ideal conditions until we try it ourselves. The outcome is usually the development of a greater respect for the people who produce those spectacular images that grace the pages of magazines and books.

Among these photographers there is a philosophical point of departure in which purists maintain that a subject must be shot in its natural setting 'as you found it' for an authentic rendering. Others believe that any reasonably accurate

representation of the subject within its setting is enough to satisfy the requirement of authenticity. The latter group, for example, is not opposed to dropping background cloths behind the subject or removing minor obtrusive elements (a practice called 'gardening') such as dead leaves or bits of inorganic material. While there may be some disagreement over such details of taking a picture there is no dispute about the absolute need to respect the natural world and to avoid destroying or abusing any part of it while photographing. Special care must be taken when working in fragile habitats such as bogs or alpine tundra, and with the rare, threatened or endangered species that may live there. Nature photographers soon realise that the more they know about their subjects, the more effective their images become. As they develop their knowledge and even reverence for nature, many choose not only to 'take nothing but pictures' but especially in sensitive habitats, to 'leave not even footprints.'

Nature photographers often travel great distances to find rare and unusual subjects and therefore have to be constantly concerned with the weight and bulk of their equipment. Other things to consider are that using equipment in the field means having to work under adverse conditions in terms of excessive cold, heat and humidity as well as a higher level of general wear and tear. Not surprisingly, many nature photographers settle on specific equipment that is light and easy to work with but flexible enough to be used under the varied conditions and demands of field work.

While there is no specific job title or formal acknowledgment of a separate field for those who photograph man-made objects typically found out-of-doors, there are a lot of photographers doing this kind of work. For them, everything from the peeling paint of an old building to the specific details of an antique car or the slick texture of a brass door knob are fair

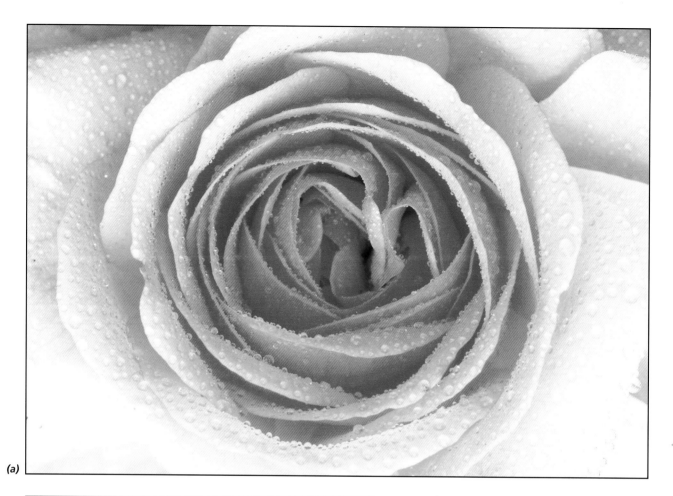
(a)

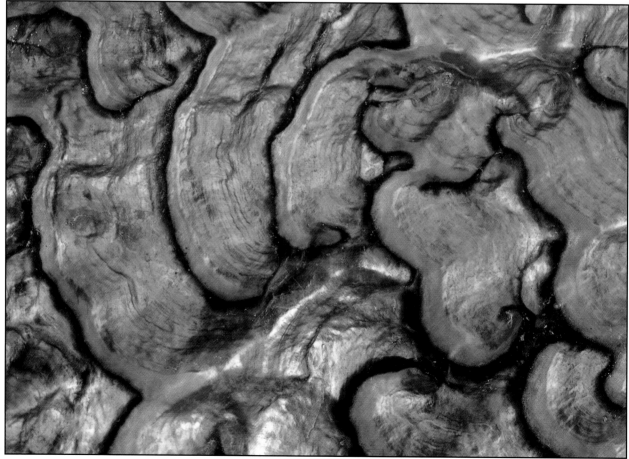
(b)

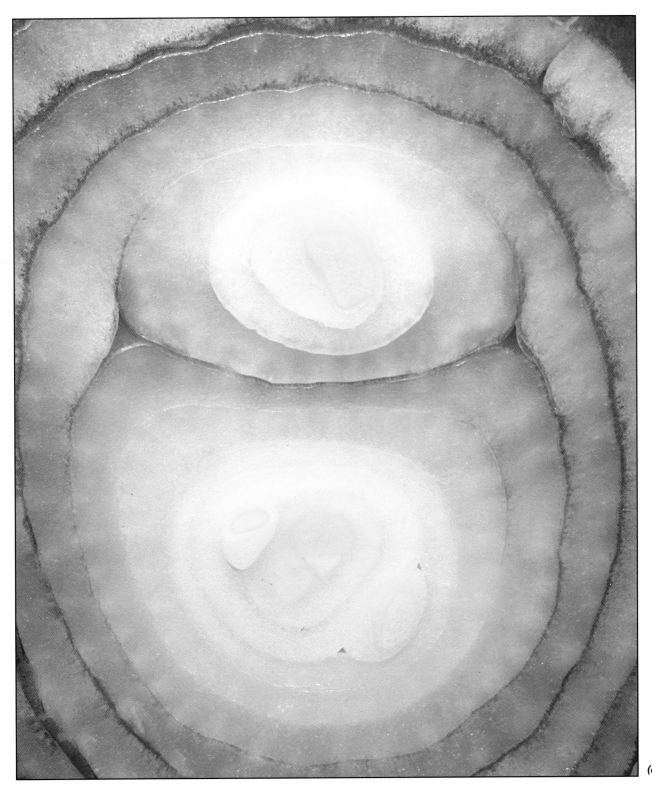

(c)

In the natural world, macro range close ups reveal often missed details as in the small droplets of water on a garden rose (a). The macro close up also allows the photographer to concentrate on just the beauty of textures without having to be concerned with the over-all structure of the subject as in (b) the interior of an Abalone shell. Even the most mundane of subjects, as in an ordinary red onion (c) become intriguing patterns at macro magnifications that can be isolated on film.
(all photos by Art Gingert using a 100mm macro lens).

game for their lenses. Even the not-so-beautiful results of man's impact on the earth as found in the corroding refuse of a disposal heap very often provide something different. Besides looking to portray this wide range of 'manufactured subject matter' in its magnified detail, they frequently look to record abstracted interpretations which disclose an unsuspected beauty in the most ordinary of products that crowd an industrialised society.

Table Top Close-Up Photography

Close-up photographers working in a studio have no such problems of carrying equipment and its protection from the elements or contending with wind and waiting for just the right light. In that sense, they have much greater control over the conditions involved in photographing their subjects. Their subject matter is also more varied, ranging from many natural subjects such as house plants, insects and the like, to man-made objects such as jewelry, stamps, coins and small objets d'art. Their main challenge is to create rather then discover those settings and conditions of background, foreground, composition and lighting that support and enhance a subject.

Commercially, these are the photographers who give us those absolutely flawless presentations of jewelry, small art pieces and even food that all require the lighting skill of a studio photographer modified and applied to work in the close-up world. There are also nature photographers working in this area who prefer to shoot their subjects under these more controlled conditions in order to do things with light and subject that are virtually impossible out of doors.

With the exception of working with available light sources such as window light, everything shot under studio conditions is done with either 'hot lights' (as in tungsten or quartz lamps) or electronic flash. In addition, a large variety of 'light modifiers' such as reflectors and diffusers are employed for even more control and flattering effects. So the thing that separates a studio close-up shooter from his field counterpart is a much greater knowledge of how to use artificial light sources and equipment. Typically, this sort of indoor photography is done on a small table, hence the term 'table top' photography. This means that a photographer can set up a studio in as little as a four foot by four foot space and later store the whole arrangement in the back of a closet. Since everything is in miniature, the lighting does not have to be powerful or the modifiers large, which makes the cost much less than that of a regular studio. The biggest technical problems faced by an indoor shooter are the highly reflective nature of typical subjects such as jewelry and the need to produce a 'natural appearance' for nature subjects such as flowers and insects. For that reason, table top shooters have to be masters of illusion.

Copy/Duplication Rephotography

One other major area of photography dependent on the principles of close-up photography can be collectively called 'rephotography' which takes in all forms of copy and duplication photography. This is the kind of work done on copy stands and with slide duplicators. Copy stands provide a very controlled setting in which 'flat work' such as drawings, photographs, paintings and sections of books are photographed to make accurate copies. While the primary purpose is usually just to make an accurate copy, there is also plenty of opportunity to experiment and create original compositions. This is typically done by incorporating such techniques as multiple exposure, zoom streaks, special filters and special lighting.

The largest volume of work done in this area is, however, straight reproduction and while all copy work is more or less close-up work, there are a few specialties which really exploit its potential. Two of these are the photographing of stamps and coins both of which often require shooting at 1:1 or greater reproduction ratios in order to record fine details. In general then, the governing principle of all copy work is to obtain as accurate a picture as possible under consistently controlled conditions.

These same general principles also apply to slide duplication in which virtually all work is at a 1:1 ratio. The idea is either to make a precise copy of the original slide or to correct some aspect of the original such as exposure or colour balance. This is all done within the confines of a close-up system, which can be as simple as shooting a slide inserted at the end of a bellows or extension tube or as elaborate as using a separate machine known as a slide duplicator which has its own light source, lens and extension mechanism as well as provisions for corrective filtration. The main problems faced by photographers who do slide duplication routinely are the control of contrast that quickly builds up in a 'dupe'; the need to get just the right colour balance in the light source; and a very high degree of sharpness so that the inevitable loss in quality that results from second generation images is kept to a minimum.

There is also the highly specialised field of scientific close-up photography, which includes processes such as crystalline photography, medical and dental photography of both gross and macro anatomy as well as microphotography. Each of these fields is directed at very specific subject matter under what is generally called 'documentary conditions.' That is, the final image has to be as accurate as possible for use in the scientific community. We will not be dealing with any of these highly specialised medical areas in this book or the duplication of slides. There will, however, be some consideration given to some creative slide duplication methods.

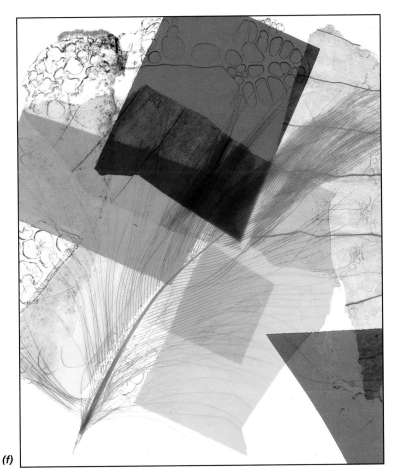
(f)

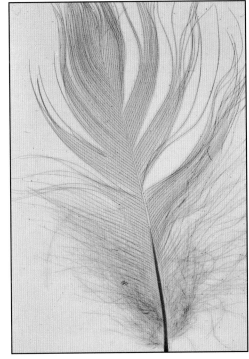
(g)

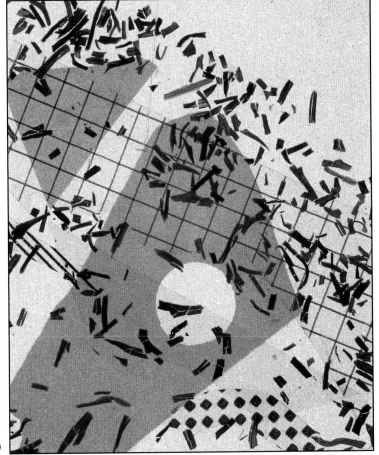
(h)

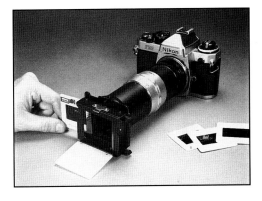

Slide duplication is a procedure based on the macro close-up which creative photographers use for purposes other than making exact copies of slides. For example, taking objects such as a feather, clips of colored gels, the bubbles of ordinary rubber cement, bits of sugar, pencil shavings, drops of coloured inks, etc., and mounting them in a double glass slide mount then photographed in a slide duplicator as shown in (f), (g) and (h) (all examples by Joseph Meehan).

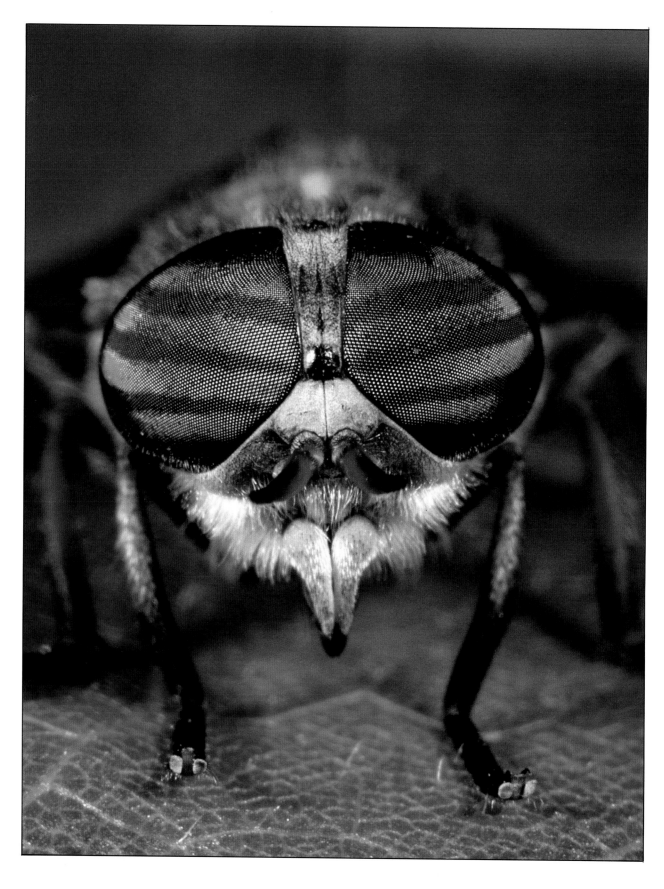

Examples of Extreme Close-Up Photography; When the degree of magnification exceeds the size of the subject itself, we are likely to see subjects as abstractions if not alien creatures as is clearly the case with the head of the fly by Bill Ivy.

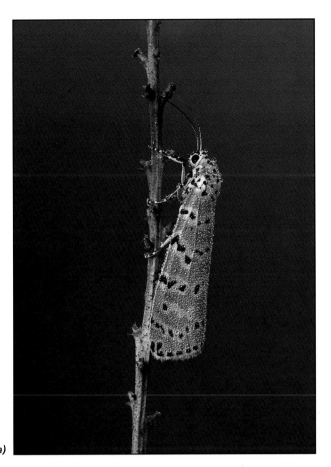

(a)

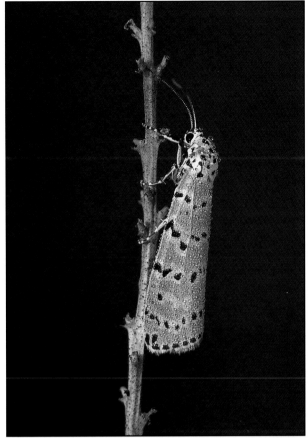

(b)

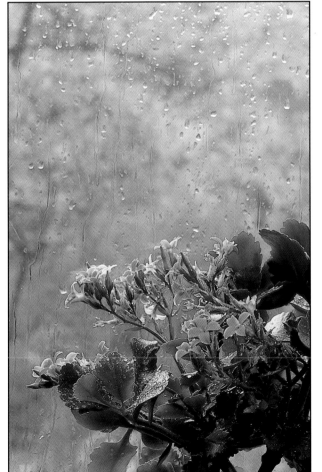

(c)

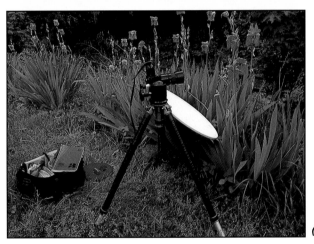

(d)

Nature photographers characteristically work under field conditions in which wind is a factor and light is ever-changing to say nothing of inclement weather. This often causes problems but the reward is to photograph a subject under truly unique conditions which change frequently as the light effects on a Bella moth in (a) and (b), by nature photographer Jeff Lepore. While in (c) Art Gingert took advantage of a rainy day situation to give a different interpretation of a house plant. Nature shooters like Art Gingert must select equipment that is light, multi-functional and easy to set up as shown in (d).

Close-ups of moving objects present serious problems for the photographer although Art Gingert's 100mm macro shot of this slow moving subject did not.

Close-up of the cuticle of a human finger shot at about 1:2, 100mm macro lens.

Some recommendations for developing close-up skills

There are a few things to keep in mind as we go through the chapters in the rest of the book discussing the equipment and methods used in these various applied areas of close-up photography. First of all, it is important to keep notes on any setup you are testing for the first time or one you are trying to perfect. It is remarkable just how much detail we can forget about a particular photograph shortly after it is made. For future reference it is useful to at least record exposure data (f/stop and shutter speed), film used, distance to subject, type of close-up equipment used (size of bellows or extension, focal length, etc.) and the light source. A small diagram (or a snapshot of the setup) is useful for studio work while field photographers often note the location, time of day, lighting and weather conditions.

Another helpful procedure is to work with a particular type of equipment for a reasonable length of time before deciding on its usefulness. In other words, give yourself time to see if your choice is going to work out. It takes a while to not only feel comfortable with a particular equipment setup or procedure but also to begin taking advantage of its full potential relative to your own needs.

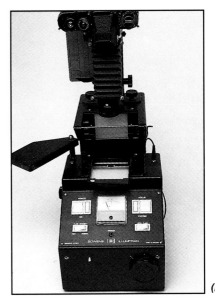

(b)

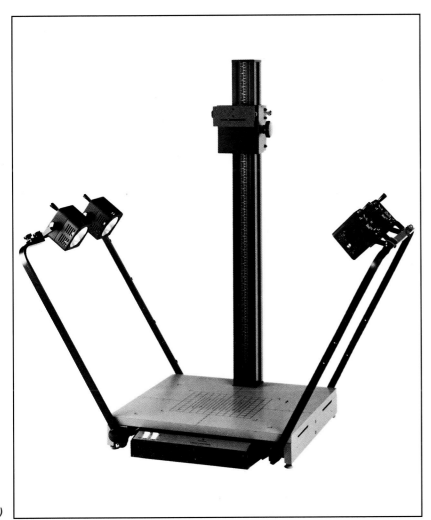

(a)

Close-up photographers who work indoors rely on a number of specialised pieces of equipment as in this Bencher copy stand with its controlled lighting (a) (photo, courtesy of Bencher Corp.) or a slide duplicator which can be as simple as this Porter's Camera Store model page 27 (photo, courtesy of Porter's Camera Store) or a more sophisticated unit as in the author's older Bowens' Illumitran (b) that uses a highly corrected enlarging lens on a bellows with a self-contained flash light source.

In Conclusion

It is a good idea to remember that close-up photography is a very different approach to making pictures and as pointed out, some of the picture taking rules are different in this field. But perhaps more importantly, the way of thinking about the subject matter for these close-up pictures has to change as well. This is a world that largely cannot be seen through normal vision and that means sometimes having to spend time getting down on hands and knees with a camera, slide viewing loupe or magnifying glass and looking at things from that perspective. In short, there is a need to begin building up experiences with the peculiar viewpoint known as the close-up. It is also certainly worth looking at what other photographers have done, not only by reviewing books and magazines, but also by attending workshops to learn new techniques.

The one great advantage, and for many the great attraction of close-up photography, is the availability of subject matter. There are many small man-made subjects on display in the home, to say nothing of house plants, fruits and foods as well as personal

jewelry, small tools and toys, to name just a few examples. Close-up sections of larger items are also possible such as the texture of a wood panel or the fabric covering a chair as well as a section of the metalwork on a stove. There are literally endless possibilities the moment a photographer stops thinking in normal proportions and begins considering the effect of the magnified close-up perspective. The possibilities for dramatic images are even greater if the photographer is willing to experiment with unusual or even abstract renderings.

The key then, is to change one's perspective early on and become as curious and exploring as possible. In that sense, getting involved in close-up photography can have an expansive effect on one's creative output, leading into new directions. That, perhaps, is the most important outcome of becoming involved with this sort of picture taking. It really does open up new doors and the opportunities to create and record largely unseen examples of subject matter which only the magnifying eye of the close-up lens can disclose.

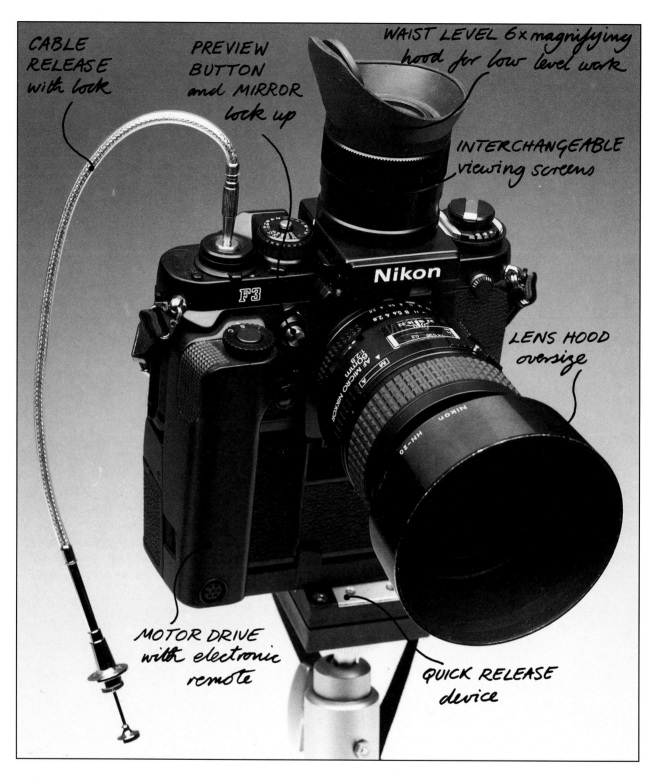

CABLE RELEASE with lock

PREVIEW BUTTON and MIRROR lock up

WAIST LEVEL 6x magnifying hood for low level work

INTERCHANGEABLE viewing screens

LENS HOOD oversize

MOTOR DRIVE with electronic remote

QUICK RELEASE device

Selecting a Camera for Close-up work. Close-up photography can be done with any SLR camera provided the lens used can produce a 10:1 or greater magnification ratio. There are, however, a few key features that are very useful if not critical in some circumstances, as when the magnification reaches 1:1 or greater.

For example, mirror lock up, interchangeable viewing screens and prisms, TTL metering for both ambient and flash.
Other useful accessories include a cable release, lens hood, 90 degree eye viewer and focusing rail, most of which are shown here on a Nikon F3 camera (photo by Joseph Meehan).

CAMERAS, LENSES & COMPOSITION

The overall purpose of this chapter is to first consider those camera features that are important to close-up photography followed by a look at the choices in close-up lens arrangements. There will then be a review of those critical principles of composition that are helpful when using this equipment. The information on lenses will be presented in relation to the three categories of close-up photography (moderate, macro and extreme) discussed in the last chapter, while the information on composition will follow a more general discussion concentrating on those points that are at work throughout the whole range of close-up photography.

The best way to go about the review of the equipment is to first describe the various choices, pointing out how each achieves its effect as well as any important advantages and disadvantages. Recommendations will then be made for each of the three categories, taking into consideration ease of operation, image quality and cost. This approach will allow readers to make specific equipment choices based on their own goals, shooting conditions and resources. We will also consider the importance of selecting some other smaller but important accessories.

Camera Choices

The modern 35mm SLR camera is a marvel of technological achievement with many features that are particularly useful to the close-up photographer. Most important is the single lens reflex design itself that allows the photographer to see what the film will record with any lens or lens accessory in place. Without the SLR design, close-up work is a far more difficult and time consuming process. Another key feature is the commonplace use of TTL or 'Through the Lens' metering in which sensors in the camera measure exposure from the light that is actually coming through the lens to make up the image on film. The great advantage here (as pointed out in the last chapter) is that TTL metering compensates for the additional exposure required when focusing closer. This type of metering has now become the basis of the 'dedicated flash exposure control' systems found in many electronic cameras. Thus, the amount of light

from the flash is also measured TTL, making for a far more accurate exposure then typically occurs through the external 'photo sensor' on an automatic flash unit.

Another lesser but still important feature is the motor winder or motor drive that is now often a built-in feature. This eliminates having to manually advance the film with one's hand, possibly moving the camera slightly out of position. It also allows a close-up photographer to react quickly to a moving subject such as a crawling insect. Interchangeable viewing screens and viewing prisms are also valuable features. Very often the viewfinder image using an 'all-purpose' screen that comes standard in the camera is quite dim as a result of using slower macro lenses with light-robbing extension tubes or bellows arrangements. If this is coupled with working under low light conditions as in the deep shade of a tree, then it is helpful to be able to change to a focusing screen that is designed for low-light work. Many of the standard focusing screens will actually experience 'blackout' under low light conditions. This is especially true of split-screen designs where one half of the split center circle goes completely black forcing the photographer to focus using the ground glass portion of the screen.

A darker image and blackout is also the result of stopping down a lens in order to visually see the effect a particular aperture has on depth of field. This is the function of another important camera feature, the 'preview' or 'depth-of-field button'. It is most often located on the camera body and pressing it physically closes down the aperture to whatever f/stop has been selected. In low light situations with small apertures and especially in the extreme magnification range, the degree of darkness can be so great that the photographer cannot see enough to make a depth of field determination. 'Previewing' is more useful in the macro and moderate magnification ranges and in bright light in general.

Since much close-up work in the field is done at a very low position, there is a real advantage to having the option of removing the eye-level prism and installing a 'waist level' prism in order to be able to look down into the viewing screen. An alternative to this is a 90° eyepiece extension that slips over the regular eye level prism's eyepiece giving a laterally correct and unreversed image. Either of these options

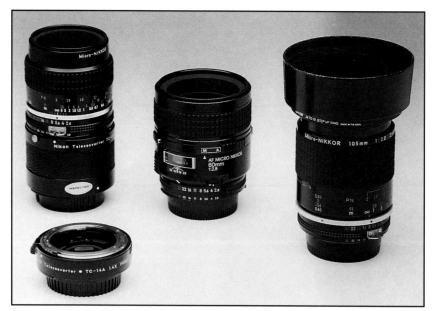

The best equipment choice for moderate close up photography where working distance is not a factor is a 50-60mm macro lens (centre). This is also the best all-around focal length for copy stand work. If working distances of two or three feet is required consider using a 100mm macro (right) instead. This focal length, however, is not nearly as useful on a copy stand. If there are only occasional times when more working distance is required a 1.4x or 2x tele-extender can be used with a 50-60mm macro (left). The greatest single advantage beyond the excellent optical quality of a macro lens is that the focusing range extends continuously to infinity unlike most other close up arrangements such as a close-up lens or extension tubes (photo by Joseph Meehan).

The equipment recommendation for macro range close-ups is again the macro lens for the reasons stated in the moderate close-up caption with the stipulation that the 50-60mm (right) or 100mm (centre) macro are capable of a 1:1 magnification. Otherwise, the use of a 10-25mm extension tube (left) will be required. The choices between these focal lengths will depend on the working distances imposed by the subject. The 50-60mm focal length is more flexible for studio work as in table top and copy stand work down to 1:1 whereas the 100mm is a better choice for field work (photo by Joseph Meehan).

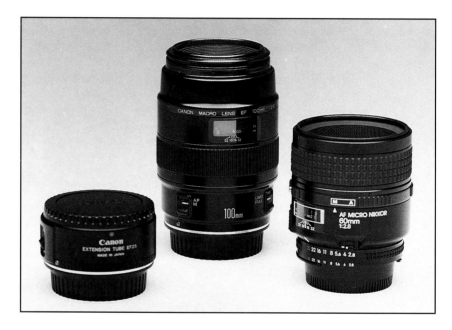

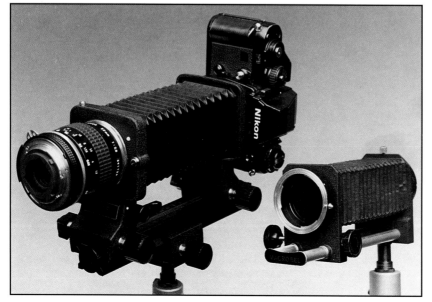

Equipment recommendations for extreme close-up photography are based on the adjustable bellows and a lens mounted forward or reversed. The exact focal length will depend on the desired magnification ratio and required working distance as described in Figure 2, page 42. Most bellows work is done with a double cable release as seen in (a) (left) where pushing the cable plunger (not shown) half way closes down the lens for metering and depth of field check. This higher end model also has its own built-in focusing rail whereas the less expensive model (right) does not (table top shot by Joseph Meehan).

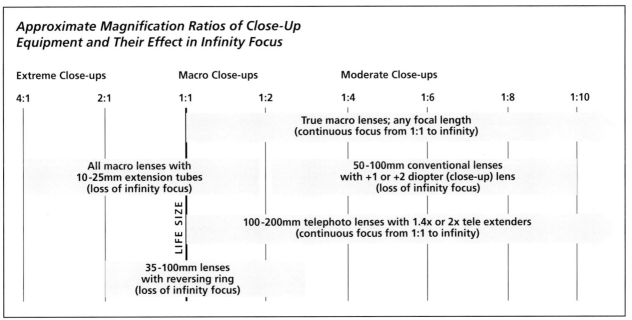

Approximate Magnification Ratios of Close-Up Equipment and Their Effect in Infinity Focus

Extreme Close-ups | Macro Close-ups | Moderate Close-ups

4:1 2:1 1:1 1:2 1:4 1:6 1:8 1:10

True macro lenses; any focal length
(continuous focus from 1:1 to infinity)

All macro lenses with
10-25mm extension tubes
(loss of infinity focus)

50-100mm conventional lenses
with +1 or +2 diopter (close-up) lens
(loss of infinity focus)

LIFE SIZE

100-200mm telephoto lenses with 1.4x or 2x tele extenders
(continuous focus from 1:1 to infinity)

35-100mm lenses
with reversing ring
(loss of infinity focus)

Figure 1

is important to photographers who do a lot of low level work. While the 90° eyepieces are a bit more difficult to work with, they do preserve the metering system of the regular SLR prism and are the only option for those cameras that do not have removable prisms. Many waist level prisms, especially in older cameras, have no metering facility.

One very desirable feature, which is unfortunately not more common, is a mirror lock-up lever. This is a device that locks up the SLR mirror before the exposure, thus removing a possible source of vibration during exposure that can occur even on a solid tripod. This feature tends to be offered only on the top professional models. Manufacturers claim that they have been able to dampen 'mirror slap' to such a degree that it is not a factor in image sharpness. That may be true at normal distances where the use of slower shutter speeds at high subject magnification are not nearly as common as with close ups. But most close-up photographers see the mirror lock-up feature as more and more critical as the magnification ratio increases.

Modifying Conventional Lenses for Close-Up Work

Converting conventional lenses that are already owned into close focusing lenses is the least expensive approach to close-up work and is definitely the way to go if this sort of work is only going to be done occasionally. Keep in mind that the overall quality that can be expected will depend on the quality of the prime lens. The following methods of making a lens focus closer can also be used with any macro lens which is already designed to reach a shorter minimum distance. The macro lens has, however, some additional advantages which will be covered later.

A lens can be made to focus closer by one of four

Equipment Recommendation for an SLR Close-Up Camera

Such features as autofocus and a range of auto metering modes are not necessary nor even desirable for an SLR camera to be used for close-up. All that is required is manual TTL metering and manual focus. What is essential is a complete range of shutter speeds (including 'B' for time exposures) and f/stops since there will be many occasions when the choices in the exact exposure have to be made by specifically changing either the aperture for depth of field considerations or the shutter speed because of subject motion. One of the nice features of some newer cameras is their ability to make timed exposures longer than the usual one second maximum on older cameras, in many cases up to thirty seconds. Other important features to have are a preview button to check depth of field, PC connection for connecting the extension cords of an off-camera flash and a self-timer for when you have to hold a reflector or diffuser next to the subject.

A built-in film advance mechanism such as a auto winder is a 'nice to have' feature as is the ability to change viewing screens and prisms. A 90° angle, eye viewing accessory is probably the better overall choice for low level work because it preserves the TTL metering feature. If you plan on doing a lot of work at the 1:1 and greater reproduction range, then give some serious thought to investing in a camera with a mirror lock up feature. This is not a consideration if you plan on working extensively with flash. In that case, consider purchasing a camera model that has a dedicated flash option.

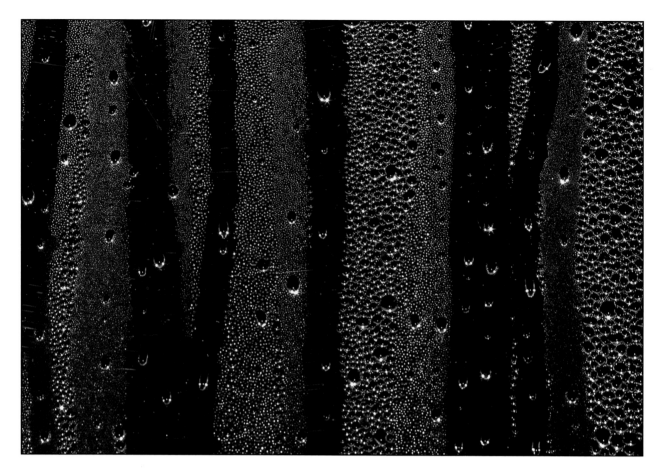

commonly used methods: (1) By extension; increasing the space between the lens and the body of the camera with the use of extension tubes or an adjustable bellows. (2) By supplementary lenses; known also as diopters or close-up auxiliary lenses which are attached to the front of the lens. (3) By using a reversing ring; a special adapter which allows a lens to be mounted backwards on the camera. (4) By using a tele-extender or tele-converter; a secondary lens used between the camera's lens and the camera body that multiplies the focal length of the prime lens. Each of these choices has certain advantages and disadvantages, summarised as follows.

Extension Tubes and Bellows Units

By increasing the distance between the optical center of the lens and the plane of focus with either an extension tube or a bellows, the lens can be focused closer to the subject. The greater the length of extension, the higher the magnification ratio as calculated by the following simple formula:

$$\text{MAGNIFICATION} = \frac{\text{LENGTH OF EXTENSION}}{\text{LENS FOCAL LENGTH}}$$

For example: the magnification ratio for a 50mm lens with 10mm of extension is 1:5.

Extension tubes are relatively inexpensive and come in various sizes which can be stacked together for more length and magnification. There are also models that have built in helical designs to alter the length of

Another consideration in the selection of a close-up lens is whether or not it is a 'flat field' optic. That is, the amount of correction for sharpness and contrast is far more even across the image recording area then would be for a conventional lens.

This is especially useful when the subject matter is flat as in copy stand and slide duplication work or as here in Art Gingert's shot of frost melt across a window taken with a 100mm macro flat field lens.

the tube without having to change to smaller or larger tubes. These designs are, however, significantly heavier than the non-adjustable types. One interesting system called the Zork adapter combines several adjustable tubes in a unique arrangement that allows the camera to be set above or below the subject.

Extension tubes enable any lens (fixed focal length or zoom; conventional or macro) to focus closer and given enough length, will produce a true macro focusing optic and beyond. They are most commonly used with normal and moderate telephoto focal lengths in the 85-200mm range and most models today maintain the camera's automatic metering system, though not the autofocus function. Any form of extension will, however, result in the loss of the lens' ability to focus to infinity, and there is a need to adjust for additional exposure as a result of the increased distance between the lens and the camera.

Working with several non-adjustable tubes at high magnifications to get a very specific composition is often difficult. This is because the composition at high

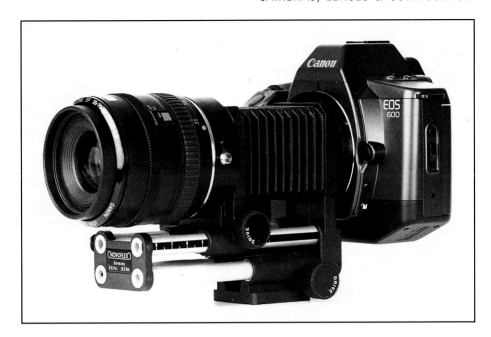

The bellows model pictured here made by Novoflex is designed to allow wide open aperture readings and auto-aperture coupling without the need of a double cable release (photo courtesy of Calumet Professional Imaging).

magnification is so tight that small adjustments often have to be made in the magnification ratio in order to get the exact framing. The ratio needed for such framing is often between the sizes provided by the tubes. Furthermore, when several tubes are stacked together the result is a long and somewhat unwieldy piece of equipment that is mounted on a tripod at the camera with the weight of the tubes and lens protruding well beyond the center of balance. A better arrangement is to have the point of attachment to the tripod in the center of all this extension, as is possible with a number of extension bellows systems.

Bellows units are generally two to three times more expensive then a set of comparable tubes, but are capable of making fine adjustments in the magnification ratio over a total range of six to eight inches or more. The average bellows alone will bring wide angle, normal and moderate telephotos into the extreme close-up range and, as can be seen in figure 1, it is possible to exceed 4:1 magnification ratios with reversed lens arrangements and wide angle lenses. Bellows units usually come mounted on a set of focusing rails with a locking mechanism, allowing the user to easily change the magnification ratio by simply racking the bellows in and out and then locking the position. The best bellows systems are those that are combined with a focusing rail since this permits the user to separately move this whole unit in and out until correct focus is obtained without having to change the magnification ratio.

The disadvantage of the bellows is that many models do not allow the camera to work in its various automatic exposure modes. This often means having to stop the lens down to take a meter reading. In other words, after focusing at the wide open aperture where the image is brightest and easiest to see in the viewfinder, the lens has to be stopped down to check the meter for the correct exposure. This method is

called 'stop down metering' and it may not sound like much of a consideration but when critically focused on a subject, waiting for a breeze to stop and with changing light, it can be very bothersome. Another annoying characteristic of some bellows is the lack of a mechanism to allow the camera body to be turned into the vertical position independent of the bellows. Lacking this feature, the only alternative is to turn the whole system to a vertical position by tilting the tripod head. Some designs also do not have room for the extra bulk of a built-in motor winder or add-on motor drive.

There is also the fact that the minimum extension for the average bellows unit when completely collapsed is usually larger then a typical small extension tube, making it impractical for use in many moderate close-up situations. Bellows are also physically larger then a single tube when stored in a camera bag, and are more fragile for field work due to the rack focusing mechanism and bellows material.

Supplementary Close-Up Lenses

Close-up auxiliary lenses are mounted on the front thread of a lens and come in the individual filter sizes such as 49mm, 52mm, 62mm, etc. They are one of the least expensive methods of making a conventional lens focus closer as well as providing for even closer focusing with macro lenses. They have the ability to change the minimum focusing distance without any loss of light. This is because they do not increase the lens-to-camera distance as does an extension device, but actually increase the effective focal length of the lens by magnifying the image before it reaches the lens, like a magnifying glass. Close-up lenses also leave the camera's automatic metering (but not autofocus) modes fully operational.

As with extension devices, however, there is also a

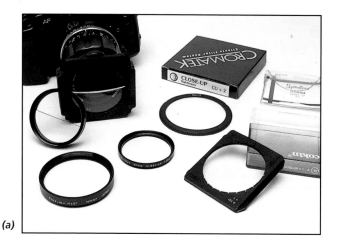

(a)

(b)

loss of infinity focus. That is, extension tubes, bellows arrangements and close-up lenses restrict the range over which the photographer can get an image in focus. Figure 1 gives some specific examples of how extension and diopter magnification restrict the focusing range of a lens.

Close-up lenses come in various strengths, with the most popular gradations being +1, +2 and +3. The higher the number, the closer the lens can be focused and, therefore, the greater the magnification ratio. These lenses, which cost just a little more than a UV filter, can be combined for an added effect as, for example, using a +1 and a +2 to produce the equivalent effect of a single +3 lens. When stacking close-up lenses the recommended procedure is to place the more powerful one on the camera lens first. There are two choices available in terms of optical design. The most common are single element models which are available in virtually all thread sizes and frequently come as a three pack kit of a +1, +2 and +3.

The greatest disadvantage of these single element designs is their often marginal image sharpness, which can be unacceptable if used with a prime lens whose quality is already not the best. In other words, they must be used with an excellent lens to begin with, otherwise the level of quality will be totally unacceptable. It is generally advisable to stop your lens down to the middle f/stops when using close-up lenses, something which a close-up photographer would tend to do anyway for the increase in depth of field.

More recently, a better-corrected version of the supplementary lens has become popular among professionals. Its performance is superior due to the use of more than one element to correct for optical aberrations characteristic of a single element design. Multi-element close-up lenses are available from camera manufactures such as Nikon, Minolta, Leitz and Canon and cost about three times as much as the single element types, but are very definitely a better option.

Close-up or diopter lenses come in a variety of configurations and strengths but all are attached to the front of the lens either as ring type or square bracket designs as seen in (a). The multi-element types are far better then the single element designs as seen in (c) where a +2 single element close-up lens has produced a slightly soft image. In (b), the use of a split field close-up lens shown mounted on the lens in (a) is used to merge a close-up of the filters in the foreground with an infinity focused background. The dividing line between the two is hidden in the sidewalk/grass line in the foreground; f/22 at 1/15 second. (All photos by Joseph Meehan).

Reversing Rings and Tele-Converters

A reversing ring consists of a thin metal ring which has a filter thread on one side and a camera mount on the other. This permits the user to first thread the adapter onto the lens front and then reverse mount the lens to the camera body. These accessories cost a little more than a set of single element close-up lenses and can be used with moderate wide angle, normal and moderate telephoto lenses. They will convert normal lenses to approximately a 1:1 optic, supplying very good image quality when used on good prime lenses.

The main disadvantage is that the user is locked into one non-adjustable magnification ratio at a very short working distance and a minimal focusing range. Reversing a lens also exposes its rear portion containing delicate linkage mechanisms and contacts to the possibility of damage. Not to be overlooked, either is the inability to use a standard lens hood without some sort of customised arrangement.

Tele-converters are separate lenses that are designed to be used between a prime lens and the camera to multiply the focal length of the prime lens. The most common grades are 2x and 1.4x producing, for example with a 50mm lens, a 100mm and 70mm optic respectively. There is a light loss with these devices that is proportional to their multiplying function; thus, a 2x results in a loss of two stops and a 1.4x converter requires a one stop increase. The working distance increases as the focal length does so

(c)

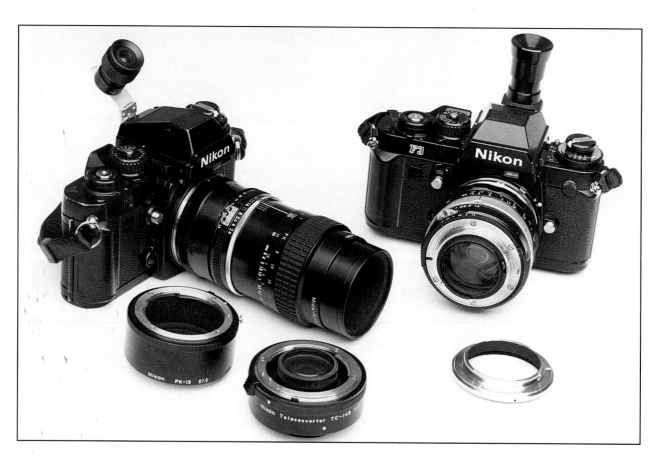

Reversing a lens with the use of a reversing ring (right) allows most normal and wide angle lenses to produce macro range magnifications with the quality varying significantly from lens to lens. Adding either a 1.4x or 2x teleconverter (left) has the effect of multiplying the focal length of the lens by those factors, usually without changing the close focusing distance. Thus, a lens with a 2x converter will see the equivalent of being focused twice as close since its focal length has been doubled. Quality here depends on the prime lens and the converter itself (photo by Joseph Meehan).

The quality of results from using a so-called 'macrozoom' are difficult to generalise about. Moreover, few actually reach a true 1:1 ratio and most have a separate button which moves the lens into a 'macro' range at only the widest focal length which in this case, is 35mm. (Close-up by Joseph Meehan on copy stand using a 60mm macro lens at f/22 $^1/_{15}$ second).

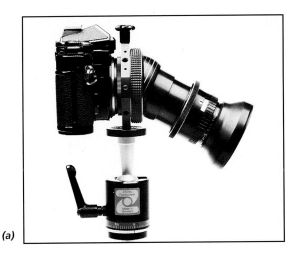

(a)

(b)

that a 50mm lens with a 2x converter can be used twice as far from the subject. In other words, in most cases when a tele-converters is added to a lens, the original minimum focusing distance of the lens remains the same. So, effectively the user now has an image that is twice the magnification of the original lens (in the case of a 2X extender) which is the same on film effect as being able to move twice as close with the original lens. The recent advances in the quality of both converters and prime lenses has made their use in close-up work a reasonable combination just below the quality of comparable macro focal lengths lenses. The cost of top of the line converters can be as much as a lens so using this combination is more practical if a tele-converter is already owned.

Specialised Close-Up Lenses: Macro Lenses, Short Mount Bellows Lenses and Enlarging Lenses

Macro lenses are specifically designed for close-up work and therefore can be continually focused from their closest focusing distance out to infinity. This is a distinct design advantage over extension tubes, bellows, reversing rings and close-up lenses and many photographers use macro lenses as both a close-up lens and a general photography optic as well. The fact that a macro lens is better corrected for closer work certainly does not reduce their longer distance performance. In addition, there is always the option of increasing the lens' on film magnification power by adding any of the four close-up approaches just covered. The most common focal lengths are 55mm-60mm, 90mm-105mm and 200m.

The major optical characteristic of a macro lens beyond their ability to focus closer is that it is a 'flat field lens.' That is, the type of correction that has been made in its performance is to have resolution and contrast be as even as possible across the whole field, hence the term, 'flat field.' Characteristically, a conventional lens will show a better level of performance at the center versus the edge of a frame. Flat field lenses are particularly desirable when working in a situation where the subject matter is flat,

Some of the most unusual and practical approaches to close-up equipment are available from Zorkendorfer Fototechnik of Munich, including a unique extension tube seen in (a) that is adjustable in length and angle for use with a high quality enlarging lens that can be equipped with a set of aperture hole inserts (b) to increase the depth of field over the minimum aperture (photos courtesy of Zorkendorfer).

as in artwork photographed from a copy stand or in a slide duplicator. There is less of an advantage using such a lens design when working with three dimensional subjects, though again, the higher levels of correction for working near to a subject and the closer focusing characteristic combine to make these lenses the favorite tool of close-up photographers. Macros also maintain all auto metering modes with ambient light as well as autofocus (if that is their design) at normal focusing distances and in those cameras using a TTL flash system they also maintain automatic metering modes and dedicated flash throughout their whole focusing range.

About the only drawback of using macros is that, as a class, they are among the slowest representatives for a particular focal length by anywhere from one to three stops. This is certainly not a factor for close-up work, where wide open apertures are hardly ever used, but faster lenses do deliver brighter images in the viewfinder for focusing and that is always appreciated by photographers who often work in dimly lit environments. Macro lenses are usually twice as expensive as comparable non-macro focal lengths. Lately there has been a trend to make new macro lenses a stop faster and that has made them even more expensive.

While a conventional lens can be used with a bellows unit, a better choice is a good quality enlarging lens, short mount lens or macro lens. Short mount lenses (or bellows mount lenses as they are sometimes called), are smaller and lighter macro lenses that have no built-in helical focus mechanism of their own but are designed for use only on a bellows. Fewer of these lenses are being made today, with more use being made of enlarging lenses and

	4:1	3:1	2:1	1:1	1:2	1:3	1:4	1:5	1:6	1:7	8:1
(Magnification Ratio)	MACRO CLOSE-UP						EXTREME CLOSE-UP				
[20mm reversed]								1.6'	1.5'	1.4'	
[35mm Reversed]							1.8'	1.7'	1.6'		
[35mm Normal]							0.36'	0.25'	0.18'		
[55mm Macro Normal]				2.3'	1.9'	1.1'					
[55mm Macro Reversed]					2.4'	2.1'					
[105mm Macro Normal]	11.2'	6.8'	4.8'								

The figures given are for the working distance, in inches, for each lenses and bellows combination. The shorter the focal length of a lens, the greater the potential for higher magnification ratios but the smaller the working distances.
Notice also, that a reversed lens gives more working distance.

Figure 2

normal range macros. Enlarging lenses are the smallest and lightest of all three lenses and like macros and short mounts they are also 'flat field' optics. While bellows lenses are equipped with a camera mount allowing them to be fitted directly to an appropriate bellows unit, the enlarging lens has to be fitted with some sort of mounting device which will attach to the bellows. Another way of looking at this is that a short mount lens is basically limited to just the bellows that uses the manufacturer's mount while enlarging lenses can be fitted with a universal 'T Mount' which permits their use on a wide variety of bellows models. Enlarging lenses have become the optic of choice with slide duplicators where a flat field is absolutely essential.

The biggest overall disadvantage in working with a bellows is the loss of the general features of wide open metering and focusing. That is, in the usual SLR camera, the lens stays wide open while metering and focusing and then stops down to the set aperture during that split second when the shutter release button is pressed. There are a few exceptions to the non-automatic type bellows and it is worth considering these models if there are plans to do a lot of bellows work under field conditions. Since enlarging lenses are, by design, preset, non-automatic lenses, stop down metering is an accepted fact of life with these optics.

Macro Zooms

Macro zoom lenses are a difficult category to generalise about because there is so much variation from model to model and brand to brand in terms of image quality and just exactly what 'macro' means. That is, some of these lenses deliver good to very good image quality in their 'macro' modes, which are generally in the 1:4 to 1:2 range. Unfortunately, there are also many macro zooms that give less then satisfactory results. Furthermore, many rely on a button to switch the lenses into a separate macro focusing range which is often limited to one focal length (usually the shortest) with a loss of infinity focus just as with an extension tube. So the question is, just what good is a zoom lens with a macro setting that does not go to a life size ratio and is limited to one focal length with a restricted focusing range? The answer would appear to be that they are useful if close-up work is only going to be done occasionally and primarily in the moderate range. Consequently, it is worth trying a good conventional zoom in the normal to telephoto range with an extension tube before specifically buying a macro zoom for close-up work.

Some macro zooms can focus continuously from infinity to a magnification ratio in the 1:4 range. If the lens can deliver good image quality, this makes it very useful in non-critical copy stand work where a fixed focal-length lens equipped camera always has to be raised and lowered on the stand to accommodate different sizes of artwork. It is also a good idea when using a zoom lens on a copy stand to shoot at the middle f/stops (which is good advice with any type of lens) and to be aware of 'zoom creep'. This is when the zoom collar moves by force of gravity after being set in position, changing the focal length and throwing the lens out of focus. This is a real possibility with the so-called 'true zoom' design in which one collar combines the functions of focus and zoom. 'Varifocus zooms,' which have two collars to handle focus and focal length settings separately, are less prone to zoom creep. 'Focus Creep,' in which the focus shifts, is another copy stand hazard with any lens with gravity again being the culprit. The zoom malady can be dealt with by placing a piece of thin tape lengthwise along the barrel to increase the tolerance between the barrel and the zoom collar. Focus creep requires a servicing of the lens.

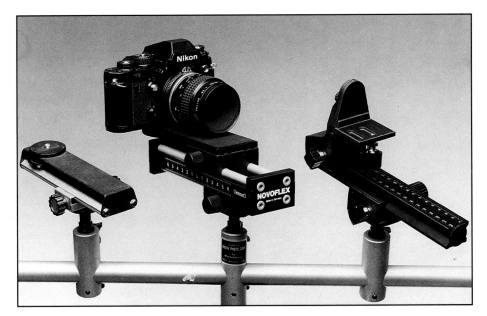

A focusing rail is a very useful accessory which changes the camera to subject distance in order to focus without having to change the magnification ratio. The Nikon model (right) is one of the largest and allows the camera to be mounted in a horizontal or vertical position with two rails for an extra long extension. Its size makes it more appropriate for use in the studio while the smaller, single rail Novoflex (centre) would be easier to carry for field work although its total extension length is more limited. Both of these are solid, well-machined units while the model (left) is not as well made and may be unstable in its longest extension position (photo by Joseph Meehan).

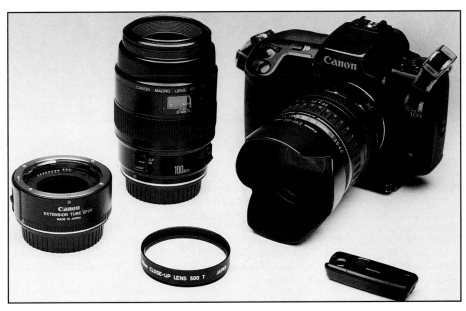

Nature photographers rely on equipment that is light and flexible as represented by this field camera outfit of Art Gingert's which was used to take several of his photographs appearing in this book. It consists of a 100mm macro lens, extension tube, short zoom and a remote sensor that allows him to trigger the shutter release of his Canon EOS 10s camera remotely.

Focusing Rails

There is one piece of equipment that should be considered as critical to any close-up arrangement used on a tripod, especially in the macro and extreme ranges and that is a focusing rail. This device fits between the camera and the tripod allowing fine focus by moving the whole camera and lens arrangement closer or further away from the subject. The advantage here is that the magnification ratio can be set up on the camera, with the critical focus left to the rail. If you had to focus using the camera and lens arrangement this would change the actual magnification ratio and exposure. By mounting the camera on the rail, there are separate and complete controls over both focus and magnification.

Most rails are designed for use with bellows units but there are those which are meant for just the camera, lens and accessory close-up devices like extension tubes. The critical factors in their design and use relate to the quality of construction and how the photographer uses them. The camera should be mounted so that when the rail is moved it does so away from the photographer; otherwise it will project from the bottom of the camera, hitting the user in the jaw. The machining should be of good quality so that focusing is not loose and when the rail is locked in position it stays there. There are single and double rail designs, and the basic difference is how far they will move the camera. You need at least four or five inches of focus displacement to make the use of a rail worthwhile, and that is what most single rail models offer. The double units can go up to one foot but they are a lot heavier and add some height to the camera as well, which could be critical if there is frequent shooting from a lower position on a tripod that is not capable of taking up a very low position. The added weight becomes a factor when there is a need to shift the camera to a vertical position which sets the bulk

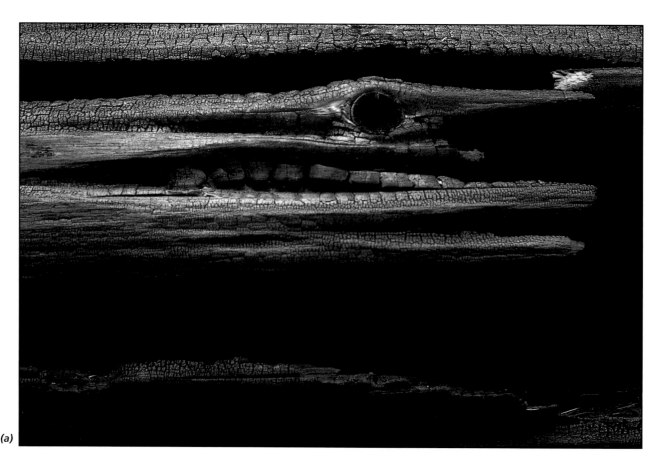

(a)

Probably the most important 'technical fact of life' in close-up compositions is the limited depth of field. To optimise the depth of field, the camera position should keep the film plane parallel to the subject's plane. In (b) Art Gingert's shot of the primary and secondary feathers of a Blue Jay, the parallel alignment of film plane and subject along with a small aperture setting on a 100mm macro kept everything in focus at a 1:1.25 ratio. In the author's shot of a burned tree log (a) the loss of depth of field caused by the irregular surface is hidden by the loss of shadow detail in the shaded areas (60mm macro, f/32 1/2 seconds). By the same token, it is possible to incorporate out of focus areas successfully as Art Gingert did in (c) opposite a 1:1.75 shot of a Lavender Iris after an early morning rain with a 100mm macro and a 25mm extension tube.

of the camera and lens to the side of the tripod's centre.

One answer to the problems brought on by having to turn the whole close-up arrangement vertically on a tripod is to use an extension tube that has a built-in revolving collar and mounting thread. This allows you to first mount the extension tube to the tripod and then mount the camera to one end, with the freedom to turn it for a horizontal or vertical shot. Other extension tubes or a bellows and finally, the lens itself, are then mounted to the front section of this special tube. This tube should also allow a motor drive attachment to clear the rail.

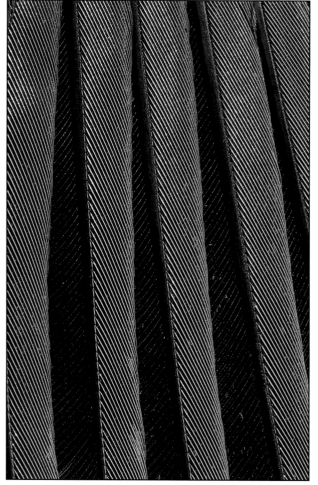

(b)

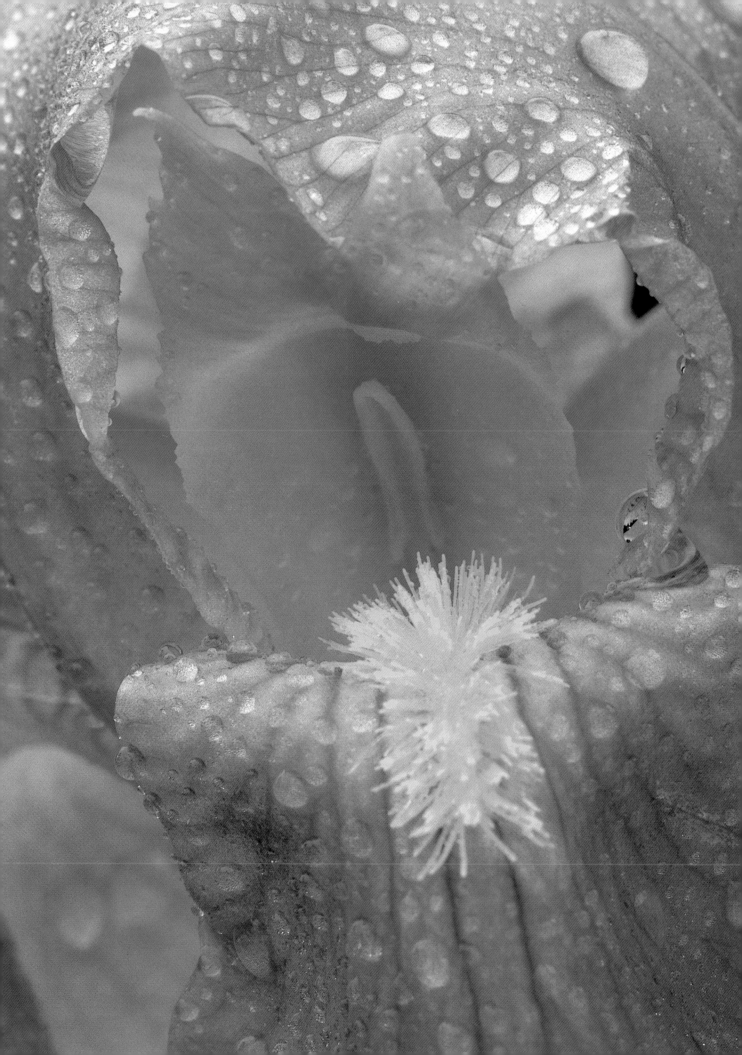

(a)

Equipment Recommendations for Moderate Close-up Work

A macro lens is the best but most expensive choice for all moderate close-up work whether it be flat field work as in copying or three dimensional subjects such as flowers in the field. The decision about which focal length to use will depend on the type of subject that dominates your work. The 50-60mm range is the most versatile and definitely the lens of choice when doing copy stand work. This focal length allows full coverage of flat work up to 20 x 24 inches or more on a typical copy stand. The short working distance of a 50mm lens compared to a 100mm or 200mm is not a real problem when working in table top situations either, since you can move the subject closer to the camera.

The drawback of the smaller working distance when using a normal lens comes in the field where it is often necessary to be at a distance from the subject. This can be overcome, to some degree, by using a good quality 1.4x or 2x tele-extender giving you the rough equivalent of a 70mm and 100mm macro respectively. If copy work is not a consideration and most of your shooting is to be done in the field or in a table top studio, then a 100mm Macro is the best all around choice because of the greater working distance. If all the work is going to be in the field, some thought might be given to using a 200mm macro as your standard lens if the subject matter is consistently hard to get close to, as in shooting into tidal pools and various bird-nesting situations.

Less expensive alternatives: A single extension tube used with a 50mm conventional lens is a good

(b)

One of the most useful arrangements of the visual elements in a photograph is the rule of thirds as shown in Art Gingert's arrangement of a tiny shell (a) surrounded by a field of horseshoe crab eggs. As the magnification ratio increases, the subject will more likely dominate the picture completely so it might be useful to think about arranging its individual structures within the thirds as Art Gingert did with the eye of this Blue Fin Tuna opposite. As the magnification increases further, the composition often comes to rest on a surface pattern or texture as in (b) Art Gingert's shot of a Ruffed Grouse's wing.

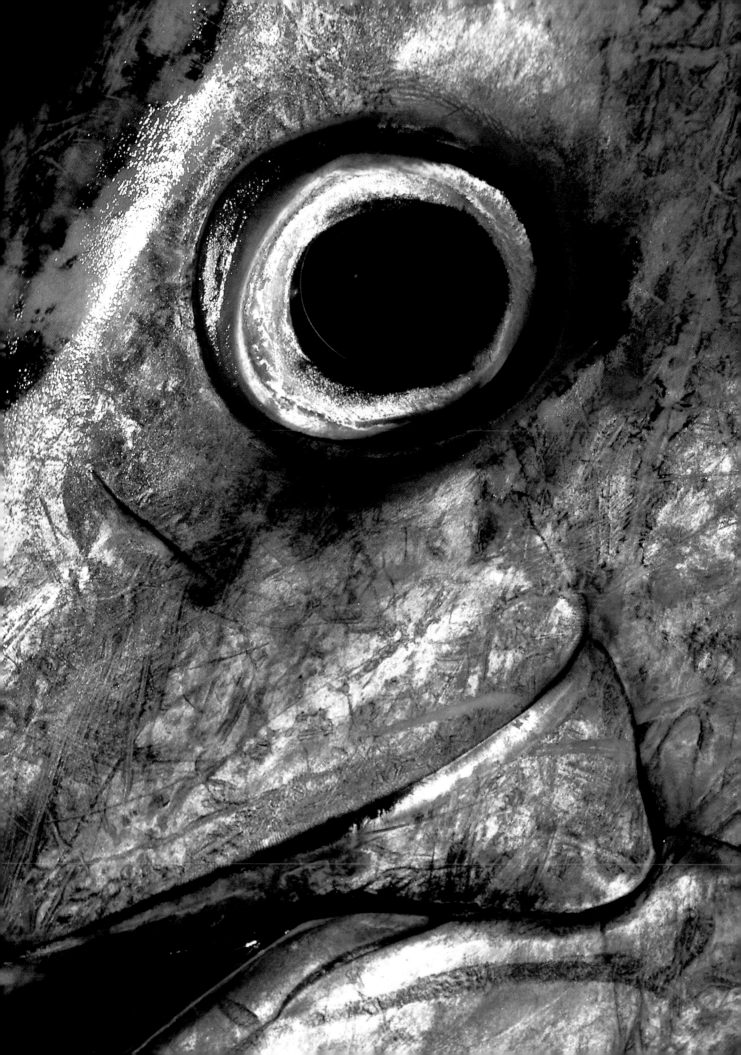

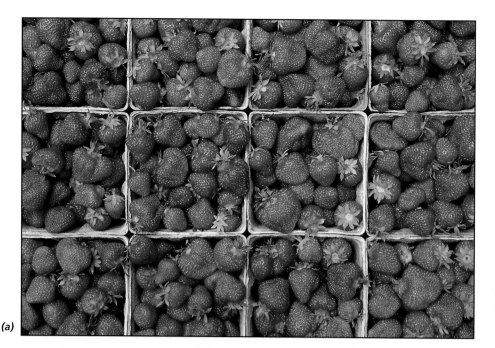

(a)

The changes in composition brought on by increases in magnification are shown here in Art Gingert's three pictures of strawberries. In the first shot approaching moderate close-up taken with a 50mm macro (a), the dominant structure are the basket holding the berries which almost form a rule of thirds grid. In (b) the berries now emerge as the subjects in this 5:1 shot while in this macro range shot (c) opposite the main element is now the texture of the berries which was secondary in (b) and hardly noticeable in (a). The final close-up was taken with a 100mm macro, 50mm extension tube and 500-T Canon multi-element close-up filter.

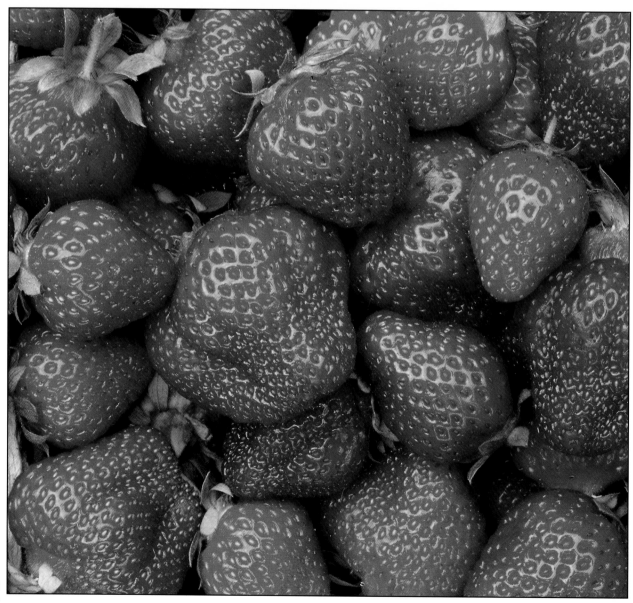

(b)

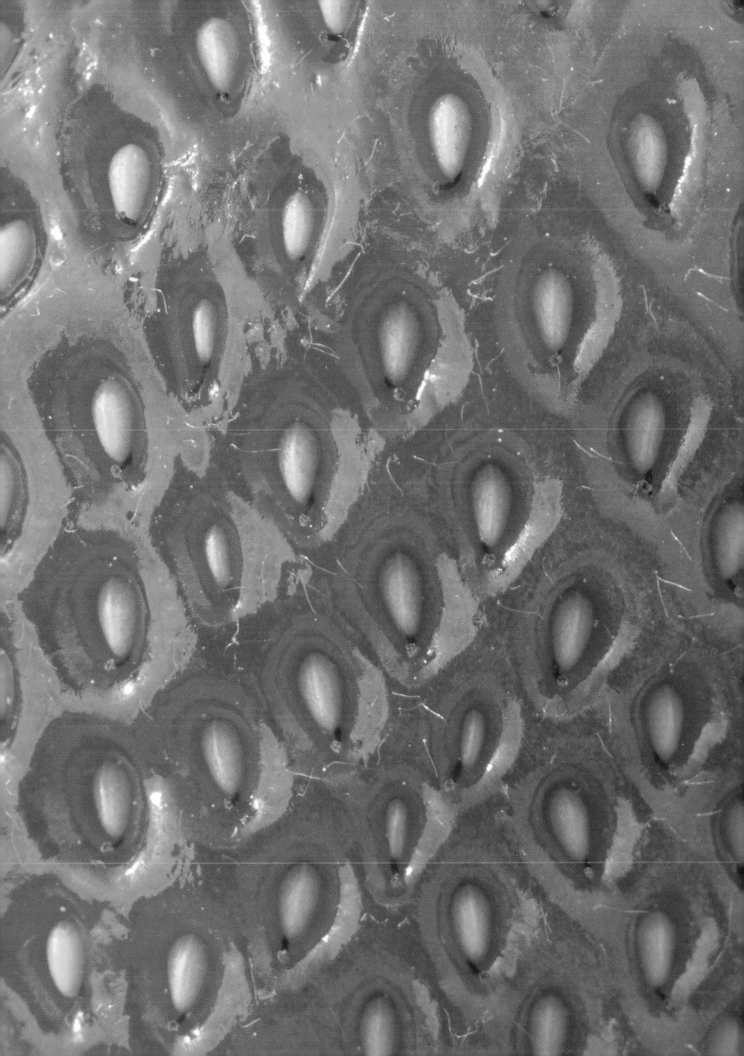

alternative for the copy stand and table top work. Use the formula for magnification ratio cited earlier to determine how large an extension is required for the specific magnification ratio relative to the focal length. You can expect very good results with these arrangements provided the prime lens is of good quality. It is highly recommended that you use automatic extension tubes. Using a multi-element close-up lens on a 50mm or 100mm conventional lens is a third alternative, and the chart on close-up lenses can help you to determine your choice.

Equipment Recommendations for Macro Range Close-Up Work

Once again, the macro lens is the best overall choice, but with the addition (if necessary) of an automatic tube extension to obtain 1:1. These lenses will give you the option to be able to work from the life size range back out to moderate close-up magnifications, all with wide open focusing plus TTL ambient and flash metering if you have the appropriate camera. Furthermore, if the macro can focus down to 1:1 without extension, this can all be done with continuous focusing throughout the range. The biggest question is focal length selection, and here the closer working distance caused by the 1:1 ratio really makes the 100mm a better focal length in the field, with some consideration given to a 200mm macro.

Generally, working at 1:1 is not a copy stand range, but if you are considering working off a copy stand only at macro or even the extreme magnifications, then a 100mm is still the better choice because of the larger working distance. If your work does include routine copy work in the moderate range of typical flat work and only occasional 1:1 work, then a normal focal length macro plus extension is the better choice, since it will cover both the larger area needed for most flat art work as well as 1:1 magnifications. In the field, this is another matter. For field work, there is no question that the increased working distance of a 100mm or 200mm is better for life size work, and if this is where the majority of your shooting is going to be, then the longer focal lengths are clearly the best choices.

Less expensive alternatives: In order of descending level of convenience are (1) the use of extension tubes to achieve 1:1 with a conventional 50mm, 100mm, 200mm or even a 300mm lens. The decision as to which focal length to use depends on the required working distance as was just reviewed for macro lenses as well as which focal length is already in one's camera bag. (2) Another choice is a 1.4x or 2x tele-converter and the equivalent of a +1 multi element diopter with a conventional 100mm to 200mm lens. All of these will give you some limited flexibility in working distance and focusing range. (3) The least expensive approach that will deliver quality

(a)

Even with an obvious subject such as the author's 50mm macro shot of an old sign (a), some thought should be given to the most interesting view and framing. Here the framing is such that the viewer has to do at least some work perceptually to complete the circular design of the subject that is partly out of the frame while the side light indicates something about its texture. In (b), the use of a diagonal framing by Art Gingert adds a dynamic quality. Here, there are actually three diagonal lines going through the picture as formed by the perch, the direction of the head and the leaf. Close-up photographs as a class give the photographer more opportunity to compose with textures only as opposed to normal distance photography and, in fact, are frequently based on the isolation of a pattern as in Art Gingert's shot of a mass of lavender ornamental Kale leaves (c).

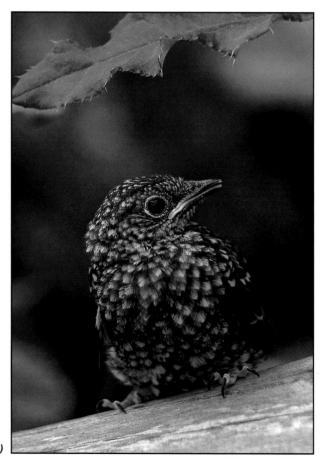

(b)

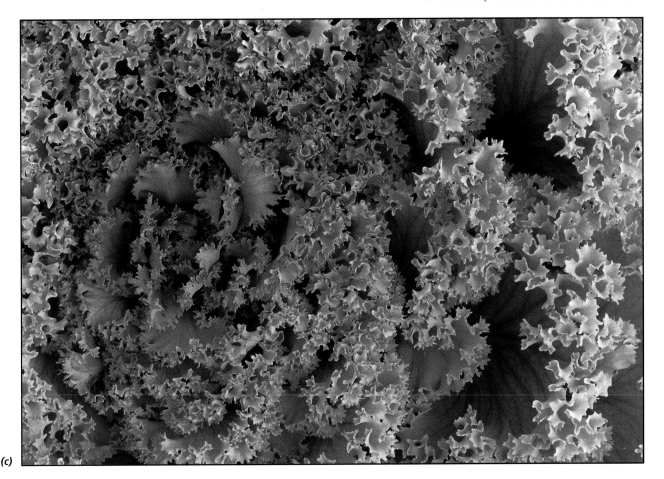

(c)

comparable to the best of these alternatives is the use of a reversing ring on a normal lens, but here you are limited to one magnification ratio and a very narrow focusing range. In all cases, stay away from the use of single element diopter designs in these combinations unless your budget is very limited. It is also very difficult to make exact assessments concerning the image quality for each of these different arrangements because of the differences in the specific prime lenses and secondary lenses (close-up and tele-converters) that may be used. In general, a macro design in the three forms we have discussed here will deliver the highest overall quality, and an extension tube, because of the absence of any secondary lens, will change the performance of the prime lens least. The best quality tele-converters have to be ranked just above the best of the multi-element close-up lenses, but this may not be detectable in many arrangements.

A bellows with a macro lens, short focus lens or enlarging lens is another alternative that will deliver macro lens equivalent quality. But the question as to whether or not to go this route will depend on the magnification of the majority of your work. If it is at the macro and extreme range then very definitely consider this as your setup. Otherwise, stay with the macro lens and extension tubes because of the options for wide open TTL metering and focusing as well as TTL flash throughout the whole moderate to close-up to macro range. While some bellows units offer a degree of automatic functions, they cannot operate over the whole close-up range of 1:10 to 1:1 because of the limited ability to fold down the bellows. The best focal lengths to use with a bellows are in the normal to short telephoto range or a reversed normal lens.

Equipment Recommendations for Extreme Close-Up

The best choice is a bellows unit as described above with a macro or enlarging lens in the 50-100mm range. This setup gives you the best control over magnification ratios and focus as well as covering the furthest range of extreme magnification ratios. There should also be the option of a reversing ring to increase the range of possible magnifications which can be done in this manner without loss in quality.

Less expensive alternatives are to use appropriate extension tubes with normal to short telephoto (conventional or macro) lenses used in the regular or reversed position and accept the inconvenience of limited control over magnification ratios. Using larger telephotos such as a 300mm with stacked extension tubes including helical focusing designs really makes for a very heavy and clumsy package to mount on a tripod. In this respect, the Zork tubes represent an interesting alternative. If, however, you are only going

*One of the challenges of close-up
photography is to include
backgrounds and foregrounds
and relate them to the subject as
photographer John Gray was
able to do in this unique rain
splattered window shot.*

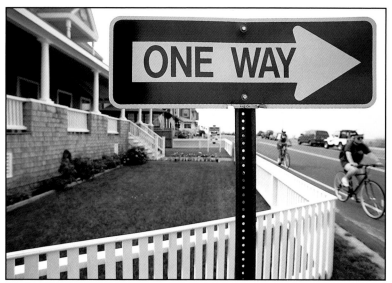

(a)

An important technical point to keep in mind when dealing with backgrounds is that while aperture will control the focus of such areas via the principle of depth of field, the focal length of the lens used will control how much of the background will appear in the picture by virtue of its angle of view. This is illustrated by the author's shots of a one way sign taken (a) with the 75mm setting of a 75-300mm zoom and again (b) with the 300mm setting.
The size of the sign is maintained as approximately equal by coming closer in the 75mm shot.

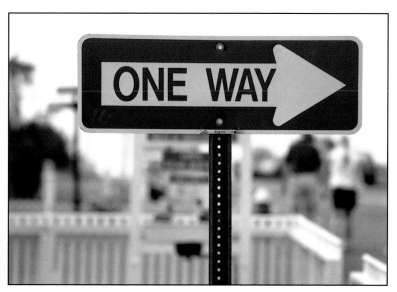

(b)

to venture into the extreme close-up range occasionally, then the use of extension tubes with a conventional 100mm lens is a viable alternative.

Composition in Close-Up Photography

If you look at a collection of close-up pictures that are regarded as successful images, the one thing they will all have in common is that there will be no confusion about the subject of the picture. Characteristically, the visual elements will be so organised as to present the point of the whole picture in an unambiguous fashion to the viewer. That does not mean that there are no subtleties in the arrangement of the subject material; on the contrary, such 'sub themes' may also be present but they will derive their very existence from the strongly stated main theme. Consequently, the key to effective composition is that all the visual elements in the picture, especially the main subject, are arranged to say something clearly to the viewer.

Successful organization for clarity is the end point of a process that begins when something catches the eye of a searching photographer. It may be the shape of some leaves, the colour of a flower or the texture of water droplets on metal. The important first step is to identify what it is that has drawn the attention; then begin to build the picture around it. In the case of a table top close-up shot, the same conditions prevail; only here it is more often an idea in the mind of the photographer to photograph a particular subject in a certain way.

It must be said at the outset that this process of finding (or thinking of) something to shoot does not always result in a picture. The original attraction or idea may not be strong enough for the photographer to build the necessary components for a complete, albeit interesting, picture. Often, the result is closer to what is often called a documentation type picture in which there is a clear, sharp and very exact but not terribly interesting picture of the subject. What makes an interesting picture is one in which some combination of elements such as flattering light or an

interesting and supportive background, foreground or perhaps secondary subjects support the main subject and make it stand out in some interesting way.

Let's assume that a strong subject is found and the photographer now begins to arrange the camera viewpoint and consider what can be done to bring together all the components present. That almost always means not only organizing the important components so that they work to support one another but also to remove or at least mitigate any distractions that will take away from the totality of the picture. So basically, a photographer has to look to remove things that might work against the subject as well as those that work for it.

Organising the Picture

Most photographs have a specific subject, and a 'ground' against which it is set; in other words, a foreground and a background. Frequently, close-up photographs lack a definite foreground, much like a formal portrait. Placement of the subject within a background setting invariably brings up the so-called 'rule of thirds'. This principle has its roots in the classical western tradition of art and maintains that within a rectangular frame there are certain points at which a subject should be placed in order to encourage a balanced presentation within that frame. These strong points occur where a set of horizontal and vertical lines dividing up the frame into thirds intersect across the rectangular frame. By placing the main subject at one of these points, the photographer provides a predictable line of interest in which the viewer is first drawn to the strongest visual element (the subject) and then out into the rest of the picture. This usually works, providing that no other stimulus in the frame competes with the main subject as in a bright 'hot spot' of light striking a nearby leaf in a picture of a flower. It may seem that placing a subject dead center with equal space around it on all sides would be a sure way of establishing its dominance, but this actually tends to cause some confusion as to where the eye is to go after viewing the subject in order to complete the composition. That is, do we look left or right? That, in turn can lead to confusion about the relationship between the main subject and the rest of the elements in the picture. The exception to this occurs in an extreme close-up where the subject simply dominates the whole picture and there is no space for any distracting elements.

Complementary to the rule of thirds is the concept of negative space in which the placement of the subject is balanced by empty space, as in the use of a very dark or even black background. Alternative forms of a negative space effect can be achieved with textured backgrounds as typically found in a natural setting where a beautiful flower is set against a carpet of identical leaves that lose their individuality, blending into a textured pattern. The same thing happens in a table top setting when an object is placed on a textured background. The characteristic of negative space is that it contains subject matter that does not compete with the main subject but either balances the subject in its 'thirds placement' or in some way complements the subject.

In a sense, backgrounds can be negative spaces that act to frame a subject, and here again one must be careful not to introduce something that is going to compete with the subject. For that reason, a flattering light falling on the main subject framed by a simple background of black cloth or some other plain background is a very safe composition. These are quite easy to arrange in a table top close-up studio where fabrics and background papers can be used. In the field, other techniques have to be employed such as dropping a black cloth behind the subject and relying on limited depth of field to drop out any chance of details (such as folds in the fabric) from being recorded. Another field approach is to hold a card or other blocking object over the back of the subject, dropping the light level enough so that this area will be underexposed on film. The opposite technique is to add more light selectively to the subject with the use of a flash, and rely on the inverse law to drop the background into a zone of underexposure.

All of this arranging of elements has to seen within the framework of the most important technical characteristic of close-up photography; the problem of limited depth of field which often mandates where the photographer can place the camera. In other words, the need to keep the camera's film plane parallel to the subject's plane or 'paralleling' as it is sometimes called, has an enormous effect on camera perspective, Furthermore, the limited depth of field becomes even more influential as the magnification range approaches the macro category to the point that we can say that from about 1:1 ratios and greater, the position of the camera is really a function of the subject's plane of focus. And, that only when this technical requirement is met, can the photographer then begin to build all the other relationships such as the rule of thirds, negative space, framing, etc.

Another important quality in any composition is the part played by secondary subjects such as the 'other' cars in a setting where the purpose is to concentrate on a particular model in a collection or one flower in a grouping of other flowers. Like supporting actors in a play, secondary subjects are capable of their own distinct make up but they should not be so individual as to compete with the main subject. This is true even when these secondary subjects are, in fact, part of the main subject. For example, the single dominant leaf of a rubber plant shown as the largest structure in an image with obvious detail. Yet looking around, the

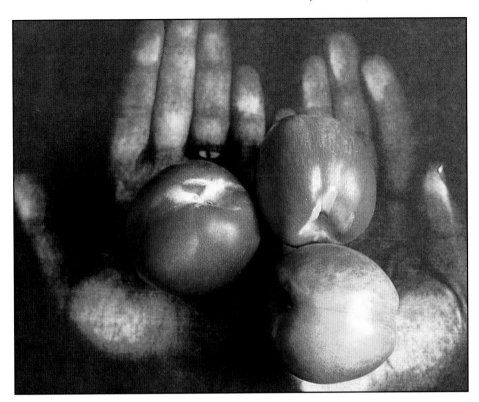

The versatility of the moderate close-up category is demonstrated in this striking example by Ivor Mitchell on Kodachrome 64 using a 50mm lens.

viewer can also see other leaves that are either in a darker setting or are much smaller. The overall visual effect is that the main subject is part of a larger structure known as a plant and the photographer is showing us the exquisite detail of its framework by concentrating on one leaf.

Guidelines for Close-Up Compositions

The first and most important step in any composition is to be very clear on why the picture is being taken. For example, is it a particular quality of the subject such as its form or texture, perhaps a combination of colours or fine details? While many times it is one or more of these points, one characteristic is more dominant than the others; thus you should try to identify a 'main theme' and work to make it the focal point of the picture. That will give you a specific direction to work towards in the arrangement of thirds, framing, negative space etc. and the reinforcement of any secondary themes or subjects to say nothing of lighting and exposure choices. When first starting out, it is a good idea to to build simple compositions following the recommendations we have covered. Then, the idea is to begin experimenting with your own interpretations. You will also notice that the guidelines don't always work and you will need to make adjustments which is another stimulus for you to begin forming your own style. For example, just placing the subject at one of the rule of thirds intersection points is often not enough for a successful composition especially if there is a competing subject in another part of the picture. That competing secondary center of interest might either

be removed or you can come in closer on the subject since size is one of the major ways of establishing dominance. Your choice of what to do in such a situation will invariably be the result of a personal interpretation.

Some key points to keep in mind when doing close-up work is that the main subject has as much importance as the face of a person in a portrait setting; that the higher the magnification ratio, the less likely the foreground and background are going to be playing any role; that paralleling must always be considered as a critical factor when deciding where to place the camera; that the amount of flexibility in a composition is generally greatest in the moderate category because of the greater depth of field and the wide field of view; that even on a copy stand, there are some options for composition as in the choice to frame the subject by introducing a frame of white space around a photograph or picture.

Keep in mind also, that once you approach 1:1 and greater, the picture is likely to be reduced to a study in colour, texture or some very small detail of the subject's make up and that such compositions become almost completely subordinate to the need to arrange the camera for what ever depth of field you can squeeze out of the setting. It is, in fact, this all-important requirement of 'parallel placement' at the extreme magnification of 1:1 and greater ratios that will often completely control the composition so that you can get as much sharpness as possible.

TRIPODS, FILMS & FILTERS

After the selection of a specific camera and close focus lens arrangement, the most important equipment questions for a close-up photographer are what tripod to use, what film to put in the camera and what filters can be used to improve the picture. The importance of these selections comes from the fact that photography is a series of interrelated steps made up of equipment choices and processes in which the goal is to produce the highest quality image. Consequently, any of these individual steps can affect the outcome in some specific way. That really comes down to the 'weak link' concept; in other words, all the money spent on a good camera and lens and the hard work expended getting the shot can come to naught if a poor quality tripod permits camera shake to spoil the picture or if the photographer does not take the time to use a quality film and appropriate filter. So, each of these 'secondary' choices needs to be looked at in some detail.

Selecting a Tripod

Many close-up photographers readily acknowledge that a tripod is their most important piece of non-picture taking equipment and should be selected very carefully. Because a significant amount of outdoor work is of small subjects at or near ground level, a tripod used in the field should be versatile enough to be configured for positions near ground level as well as the usual extended position of about 5-6 feet. To reach ground level, the tripod must have some means of easily spreading the legs outward to lower the camera. Trying to mount the camera on the bottom end of the center column is just too impractical. This feature is less of a consideration in table top work, where the height of the tripod is usually set at four to five feet. In either application, the 'pod' has to be solid in construction and capable of holding the camera without any shake.

Ideally, composition is done first in a free 'try all the possibilities' manner with a hand-held camera, with the tripod used once the camera position is selected. The tripod should also be easy to set up and adjust since its position may change several times as the photographer works to get the 'perfect spot.' In short, the tripod in most close-up work becomes as much a part of the picture-taking process as the camera and individual lenses. Considering these requirements and the tendency of photographers to modify equipment to their individual needs, it is not surprising that many photographers have a particular tripod that they reserve specifically for close-up work.

Saying that a tripod must be 'solid' may seem to imply having to carry around a heavy model. Actually, it means that the tripod is strong enough to hold its position and support extra weight, as in the case of a heavy camera bag suspended from it for added stability. While most heavy tripods are certainly stable, they are a real bother to carry around in the field, and many are clumsy to set up and adjust when lower camera positions are required. This is understandable since the majority of large, heavy tripods are designed for use with larger cameras set in an upright position.

Most accomplished close-up photographers use tripods that can be classified as moderate in size and weight, and rely on adding extra weight in the field for stability, when necessary. What is essential then, is that the model selected be able to hold this weight without the adjustments on the legs and head slipping. This means choosing a 'pod' that has well-machined parts and equipping it with a head capable of making very fine adjustments. Such models are not inexpensive, and you should expect to pay a price approaching that of a good macro lens.

Today, there is a wide range of models to choose from, each with its own set of specific features, such as square versus round legs and various locking designs. While there are a lot of well-worn arguments for and against these various features, the most critical point in the evaluation comes down to the quality of the machining in the locking mechanisms on the legs and the head. If those are topnotch, then the tripod will be able to hold a steady position with easy adjustments under the weight of a camera/lens combination and any reasonable extra weight such as a camera bag.

Tripods come in a variety of styles and sizes. For close-up work, the best choice has to be based on the need to get close to objects on the ground, to be solid and well machined so that small changes in height and position can be easily made and maintained and to be user friendly since it will be used for almost every shot. Shown here, (a) is one of the more unusual tripods, a Benbo (photo, courtesy of The Saunders Group) that is capable of of rearranging its position in ways quite different from more conventional tripods. A well made quick release device such as this QRC model from the Saunders Group between camera and tripod base is vital to many close-up photographers because of the frequent changes in camera position demanded by field work.

There is also the less tangible consideration that the user must feel comfortable with the way the tripod operates. In this regard, the best tripod in the world is of limited value if it is not 'user friendly.' This is particularly true of the type of head selected, either platform or ball type. Ball heads, with their universal joint design, make adjustments easier and quicker than a levered platform head. Once again, it is the quality of the machining that makes the difference between models. But, pound for pound, the platform design is capable of holding more weight without slippage. In addition, the platform design allows the user to make smaller adjustments in one direction at a time as opposed to taking all the weight at once in all directions as is the case when a ball head is adjusted. Larger ball heads do better at holding the weight of heavier close-up arrangements and making smaller adjustments with them, but that means having to carry around a ball head that is heavier than a comparable platform type.

Finally, if you plan to do a lot of true 'table top' work where the subject is, for example, a house plant or small toy shot on a kitchen table or mushrooms at ground level in the field, some thought should be given to purchasing a table top tripod as well. These diminutive 'pods' have a height of between 6 and 8 inches and are designed to be used literally on a kitchen table or the forest floor. Once again, stability with these models is very dependent on the quality of the machining but in most designs, this refers only to the head with the legs usually made out of one piece of metal. Regardless of how well table top tripods are made, they are not designed to hold a large and heavy close-up arrangement such as a long telephoto lens with a tele-extender. They work best with the 50-100mm lenses and perhaps a short extension tube.

Cable Releases and Quick Releases

There are two accessories that should be considered necessities. First is the cable release, which is used whenever the camera is placed on the tripod. It is nothing more then a piece of cable with a plunger attached that is screwed into the camera's shutter release button. In all-electronic cameras, this accessory is based on an electronic plug connection which closes a circuit rather then a physical pressing of the

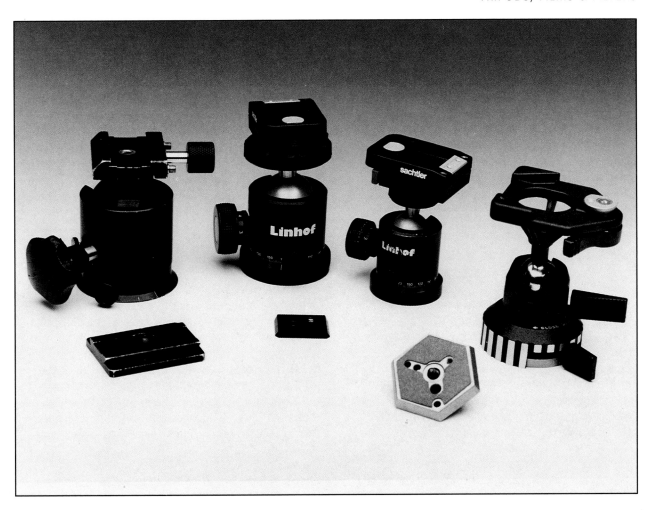

shutter release button. In both situations, the use of a cable release avoids any movement of the camera caused by a finger touching the shutter release button. Be sure to purchase a cable release that has a locking mechanism, so that the shutter can be left open (when the shutter dial is set on 'B' for long exposures) without having to hold the cable plunger down.

A quick-release device is just that; it allows the photographer to flip a lever or press a button to quickly remove the camera from the head of a tripod rather then having to unscrew the locking bolt of the tripod head each time. There are many models, all based on a two-part design in which a plate is screwed into the camera's tripod socket and a holder is then fitted onto the tripod. The things to keep in mind when selecting these devices are how well machined the fit is between the two parts; how much weight is added to the camera/tripod combination; and, finally, is it really a 'quick' release? Most important, the fit between the two parts must be snug with no play once the quick release is locked into place. The best quick releases are also the largest so there may have to be a small sacrifice in taking on a little extra bulk. Also, be sure that additional camera plates are attached to other camera bodies you may be carrying in the field.

Most photographers are familiar with the platform heads and their adjusting level arms that have been standard on tripods for years. Ball heads have recently become popular because of their ability to quickly change position in any direction.

Shown here (left) are an older Arca Swiss model used by Art Gingert with its own quick release, two Linhof heads (centre) with Sachlter quick releases favoured by the author and (right) a Bogan/Manfredo head with its own quick release device.

A useful accessory to have for testing films, tripod stability and lighting is a standardised set of colour patches with a gray scale. Pictured here are ones from

Kodak, Macbeth and Jobo as well as an example of a cut down gray card used by the author in the field for determining exposure both photos by Joseph Meehan).

Recommendations for Choosing and Using a Tripod

Select a tripod that you feel is easy to set at all the various positions you will need and is capable of being set up in very low positions for working down to 6 to 8 inches above the ground. This means avoiding a model with a long center column. Set the tripod at full height with your camera and close-up lens arrangement attached; then hang a camera bag over its platform loaded with the equipment you would typically carry in the field. Now make adjustments of a couple of inches in the leg heights. The locking mechanism should be capable of holding all this weight without having to apply an extraordinary amount of torque. Follow this by making very small adjustments of about half of an inch in the head which is typical of what would often be necessary in the field. Note how easily this can be done, and whether or not the head leaves the camera in the exact position after it is tightened without excessive pressure being applied to the adjustment mechanism.

Now, with the camera focused as close as possible and without the camera bag hung on the tripod, gently tap the top of the camera's prism with your finger (as if keeping the time of music) while looking through the viewfinder. You will notice an initial movement in the viewfinder as a result of the impact of the tap but there should be no 'aftershock' vibrations; if there are, this would indicate an unstable tripod. Try the same test with the center column racked out to its full height, and with the tripod at the lowest position.

When setting up the tripod, avoid extending the center column if you can or, if you must, extend it no more than 3 or 4 inches. This section is the most unstable part of the whole tripod. When using a camera bag for extra weight, it is not a good idea to lay the shoulder strap across a lens barrel because of the stress it places on the lens mount. Place it, instead, across the tripod's platform or hook it under the head, between the legs. Also, avoid an arrangement in which the bag may swing as it hangs, and keep the weight of the camera bag as low on the tripod as possible.

The most efficient way to use a tripod is first to find your shooting position by moving around with a handheld camera. When the viewpoint has been decided on, set up the tripod and mount the camera. This is why the use of some sort of high quality quick release device is recommended. Many photographers prefer to wrap the legs of their tripods with cloth tape or other protective material such as bicycle handlebar wrap, foam pipe insulation or the tape used on tennis rackets, to protect their hands against the cold when shooting in cold temperatures.

Selecting Films: Colour prints vs Transparencies

The most important factor in the decision about which film to use in close-up photography is the eventual purpose of the pictures taken. If these images are to be published then a high-quality black and white print (usually an 8 x 10 inches) or a colour transparency are the two recommended forms since the publication industry favors these standards. For colour prints that will be displayed, you have three alternatives available from professional colour labs for what would be regarded as 'exhibition quality'; that is, the best possible quality prints. The most common approach is to shoot colour negative film and have top quality, colour-corrected enlargements printed by a professional lab. These are hand made by a skilled darkroom worker who will make an effort to get all that a negative has into the final print by fine tuning the colour and using print manipulation techniques we will mention in a moment. This is the highest level (and most expensive) approach to printmaking, and it should not be confused with 'machine prints' in which a lab technician scans the negative once for colour and then makes a print. If you have a slide as an original, then a lab can make prints from the transparency film through a direct printing process such as Ilfochrome (formerly known as Cibachrome) or Kodak's R print process. The third approach to a final print from a transparency is to have an internegative shot done and a top-quality C print made from that negative. Each of these approaches offers certain advantages and disadvantages.

Transparency or reversal colour film, as it is also known, will give you the highest overall quality of colour reproduction and sharpness in a publication or in a presentation as in projection through a high quality side projector lens. This is because an original transparency is a first generation film image through which light is passed by viewing on either a light table or with a slide projector. As a result, an enormous amount of subtle detail can be seen as the light passes through the many layers of colour that make up a reversal emulsion as opposed to a print, which has only one layer that forms the image by the light that reflects off its surface. As a class, however, transparency films are much less tolerant of incorrect

The sharpest lens and finest grain film are not enough to produce the kind of brilliant detail seen in this 1:1 100mm macro shot of a Garden Rose by Art Gingert. It takes a well made tripod to hold the camera rock solid for a slow shutter speed release like $^1/_{15}$ or longer that is very often used on a cloudy-bright day with apertures of about f/16 to capture as much depth of field as possible.

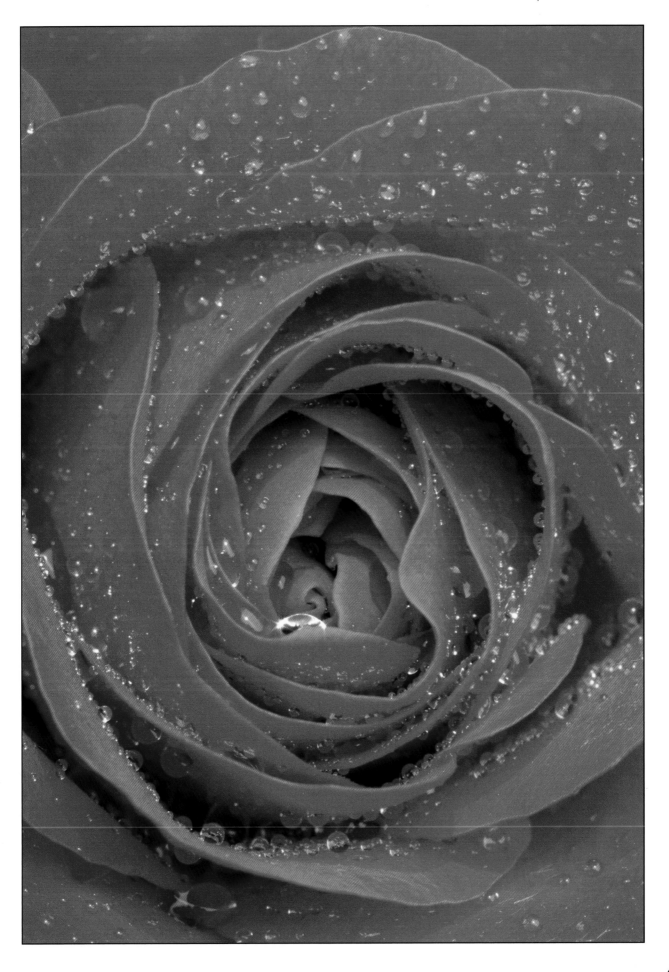

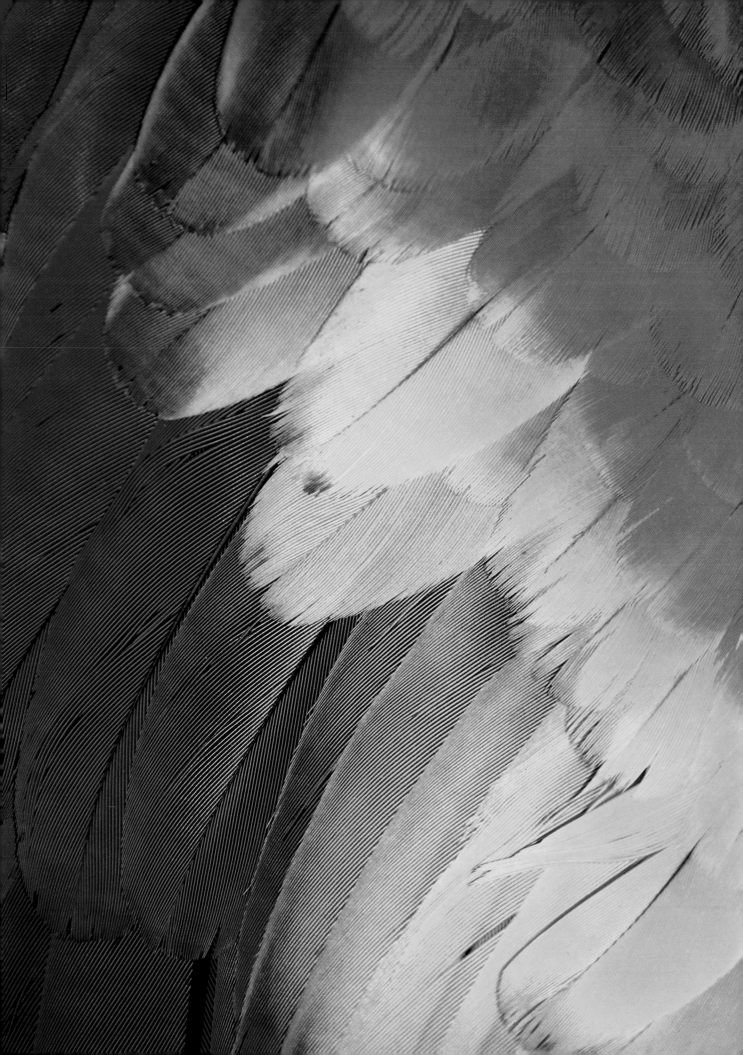

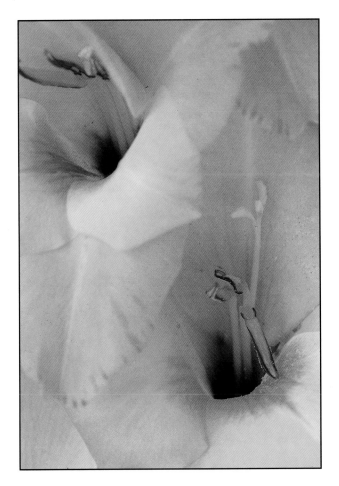

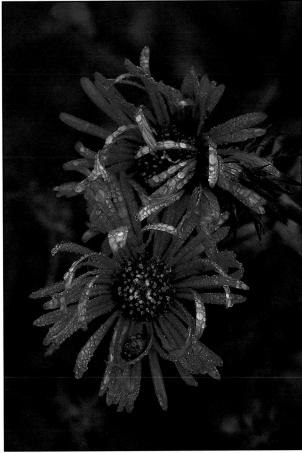

Examples of the preferred ISO 25-64 films for close-up photography can be seen through out the book beginning with Art Gingert's cover shot of a Scarlet Macaw's wing (left) and Joseph DeGeorge's flower portrait (above). In addition to sharpness, a film should also be selected on the basis of how it handles various types of lighting such as in this shady-bright rendering in inclement weather of an Aster by nature photographer, Jeff Lapore with its nine-spotted Lady Bug Beetle passenger. Film should be selected for both its ability to produce sharp images and how the photographer likes the way it handles various lighting situations.

exposure, with as little as a one-half stop error resulting in an unusable image.

Negative colour film, on the other hand, can have as much as a two stop exposure error and still deliver a usable print. This is largely due to the fact that the prints produced by negatives provide the opportunity to make certain corrections in the overall brightness, contrast and colour during the printing process. There is also the limited possibility with colour print film to adjust the lightness or darkness of certain specific areas in the print. This is done by 'burning in,' where more light is allowed to fall on a specific portion of the print and the counterpart process of 'dodging out,' where light is held back from an area. Cropping is also easily carried out during printing as the photographer makes decisions about the final size

and configuration of the enlargement.

With reversal film, there is no practical counterpart to burning and dodging and colour can be adjusted only by 'duping' the transparency with a slide duplicator using filters to make general colour changes. Customised duping services are not so widely available, and those that are tend to be somewhat limited in what they will do at a reasonable price. Most photographers find the results of duping less desirable (and less controllable) when compared to the changes that are routinely done when printing from a negative. Cropping can also be done while duping or by applying special opaque tape directly to the slide that is going to be projected; but this is a process that will often damage the emulsion unless it is first remounted in a glass mount and the tape applied to the glass. The most effective way a photographer can exercise a degree of control when taking a picture with transparency film is through the use of filters, which we will deal with later in this chapter and to some extent, through exposure which will be dealt with in the last chapter.

For many photographers, prints are unacceptable because they lack the overall quality of a transparency viewed through a good quality loupe or by projection. A print is a second generation image which has been made by the use of an enlarging lens which, no matter how good, will take away some of the original

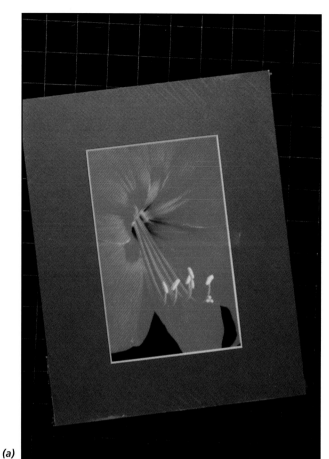

(a)

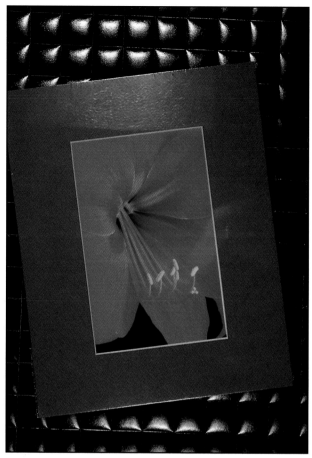

(b)

sharpness and perhaps, contrast and colour saturation. Further changes then occur because coloured filters have to be used over the enlarger light source during printing which again, no matter how well controlled, will have an effect on the original colours. Then too, a print is a single-surface medium that depends on reflected light and the quality of that light for its appearance.

On the other hand, those who favour prints over slides usually cite the greater exposure latitude and the ability to adjust the colour during printing as well as the option to burn and dodge as critical advantages. There is also the fact that an endless supply of 'original' prints can be made from one negative, while a slide is 'a one of a kind' image.

Prints made directly from slides are quite comparable to C prints and in fact, many photographers consider them to be of higher overall quality, especially in terms of sharpness. Other photographers, however, do not like 'the look' of direct process prints because of their characteristically contrasting colours. There is, in fact, a need to be concerned about printing a higher contrast image since the direct processes are notoriously intolerant of such originals. An alternative to the direct process is, as pointed out, to have internegatives shot of the slides on special low contrast negative emulsions, which are then printed in the usual manner. Many photographers favor this approach because of the

The decision as to whether to use colour print or transparency film is based on how the image will be used (publication, projection, gallery exhibition, home wall display, etc.) and the preferences of the photographer. Here, the framed close-up work of photographer April Hubbert is produced for sale making the ISO 25 Ektar print film she uses a practical choice. The author's copy stand reproduction of her work (a) on Kodak's ISO 64 Tungsten transparency film for this book was done with a 60mm macro and used polarising filters on both the camera and the 3,200° Kelvin quartz lights. Without the use of the filters, the glare from the protective wrapping would be a major problem as shown in (b). This technique can be used effectively on any subject (except unpainted shiny metal) when a polarising filter on the camera does not remove the glare.

'closer to a negative C-print look' that it gives to the final image.

As with so much in photography, the final outcome of competing processes has to be evaluated by the individual photographer and a personal decision made. The best advice is to have some prints made by both approaches from your favorite transparencies representing a cross section of low, medium and high contrast. In the end, being able to compare your own work is the only sure way of answering these questions.

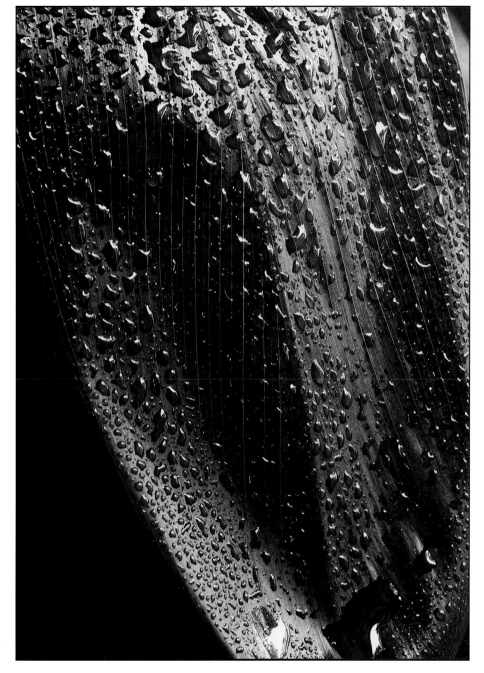

Black and white film, carefully exposed and printed, makes an excellent medium for close-up photographers. The monochrome process also offers an unmatched opportunity to refine the final image controlling contrast through initial exposure and development combinations and during printing by the use of different paper contrasts. In addition, specific areas of the print can be adjusted by adding light (burning-in) as was done by the author in the brightest highlight areas (top centre) and to blacken the shadows (lower left) of this 55mm macro shot at f/16, 1/60 second on Kodak's T-Max 100 film. Another option is to subtract light (dodging) as was done to a small degree in the lower portions of the leaf.

Black and White Prints and Transparencies

Black and white negative films, potentially, have the widest latitude of all films. This is because these emulsions are far more amenable to changes produced by alterations in exposure and development of the films themselves, and then in the printing process. The best example of how extensive these changes can be is the exposure/development process known as the Zone System. In this particular method, shades of gray are represented by zones of exposure separated from one another by a full stop of exposure.

Besides aiding correct exposure, the Zone System also allows the photographer to adjust scenes that have too much or too little contrast so that they appear in the print as having a normal range of contrast. As a result, the film's latitude can be adjusted to fit the range of contrast in the scene far more then can be done with colour print and certainly reversal film, either colour or black and white.

Successful monochromatic close-up photography is very dependent on making full use of the tonal separation of forms and details that black and white film offer. While that does not mean having to use the Zone System to work in close-up, it does mean striving for the utmost quality. The key to making a strong presentation of subject matter with monochromatic emulsions is to produce images with very fine detail and subtle separations of tones. Suffice it to say, successful black and white prints of close-up subject matter, like colour prints, can only result from careful film development and printing

High contrast films such as the Kodalith negative emulsion used by the author to make this print are excellent choices for close-ups of high contrast subjects such as printed text, diagrams or graphic designs as shown here. They characteristically record only black and white and 'drop out' the various grays that make up a continuous tone image. The easiest approach to making high contrast transparency slides is to use Polaroid's Polagraph HC which processes quickly in a Polaroid film processor.

done either by a photographer who is accomplished in darkroom techniques or by relying on the services of a custom lab.

Black and white transparencies are, regrettably, a much neglected form of presentation. There is actually only one reversal black and white film available, and that is Polaroid's Instant Polapan which is processed in that company's instant processor (manual or electric) in a matter of minutes. The only other widely available alternative is to process Kodak's excellent ISO 100 black and white negative film, T-Max 100, in a special Direct Positive Development kit. This is a seven step reversal process requiring temperature control that is best done in a darkroom with the usual facilities for processing, washing and drying film. There is also a minimum number of rolls that need to be done at a time to make it economical. Ilford also provides an option for direct reversal processing with their FP4 and Pan F monochrome emulsions with formulas provided by that company for developing chemical you can buy and mix. In all these approaches, you will also need to cut and mount the film, which is an additional step to consider although Polaroid has a very easy system for doing this with their instant films.

All these considerations aside, it is quite impressive to see black and white originals of close-up subjects projected on the screen or viewed under a loupe. Furthermore, when black and white slide copies of

original high quality black and white prints are projected (as opposed to the more common tungsten colour film copies) there is a noticeably cleaner and sharper presentation of the original print.

Guidelines for Selecting Films

If you plan to publish your close-up images on any regular basis, you should select from among the fine grain, slow ISO emulsions, typically between ISO 25 to 64. These are more or less the standards used in stock photo agencies and magazines with some use of the sharpest ISO 100 films also qualifying. In the United States, the most popular emulsions are Fujichrome 50, Velvia, Kodachrome 25, and 64. Since selling images for publication is so competitive, it is advisable to use sharp films such as these. Fujichrome 100 and Provia, Kodak's Lumiere 100, 100x, 50 and 50x represent some of the best medium speed films. Agfa's 50 and 100 speed transparency films are also excellent but tend to be used to a far less degree by professionals working in close-up. If your needs are limited to showing slides to family and friends in home settings and you only occasionally publish or enlarge a slide to an 8 x 10 print then any of the ISO 100 films available from Kodak, Fuji or Agfa will give you excellent results with specific choices a matter of personal taste.

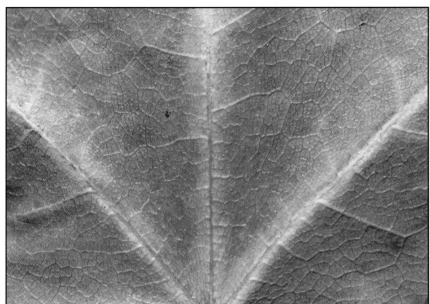

(a)

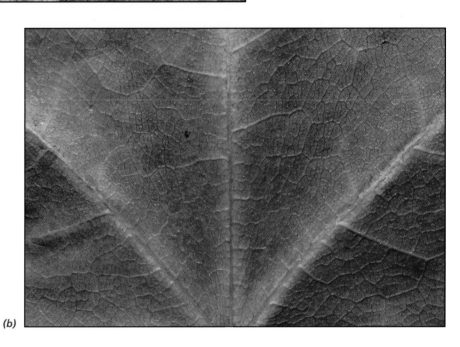

Colour transparency film is especially sensitive to errors in exposure and many photographers will bracket one half stop under and over the indicated setting to compensate as exposure insurance. But a far more useful approach, especially in close-up work, is to bracket by one third stop as was done using a 60mm macro lens on a bellows in (a), (b) and (c) on Fuji Velvia film to produce a range in different exposure treatments.

(b)

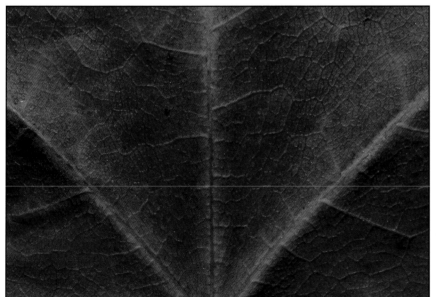

(c)

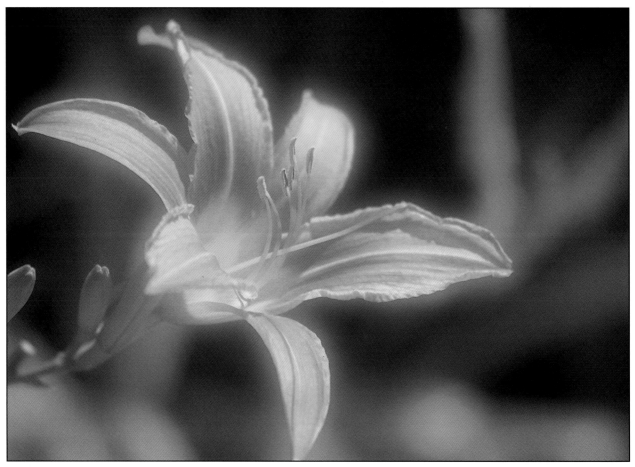

(a)

Exhibition quality prints from 5 x 7 inches and up to 11 x 14 inches from full-frame enlargements of 35mm film are generally the result of careful picture taking technique using the better equipment described in this book along with professional quality processing. Such prints can also be sold at a profit of at least three to four times their printing costs. Larger prints require an exceptional negative to produce a sharp, full colour saturated 16 x 20 inch print from 35mm negatives or slides. You can expect good quality 8 x 10 inch to 11 x 14 inch prints routinely from slow emulsion 35mm colour films. This is assuming that you have used the best equipment, a film no faster then ISO 100 and correct exposure with the print colour also corrected and with some burning and dodging if necessary. Such prints are generally hand made by a skilled lab technician who are trained to get the most out of the negative.

If your purpose is to display prints throughout your home or give them away to friends and family or perhaps exhibit and sell a few locally, then an ISO 100 film is still the standard, but you can use so called 'machine grade' prints from professional labs. Having your work done at a local one hour mini-lab is acceptable for proofing a roll, but sending negatives back to them for inexpensive 8 x 10 inch prints will not give you all that the negative has to offer. Again, the answer as to exactly how much quality difference

Bracketing in one third stops is also very helpful when dealing with the effect of certain filters, especially soft focus. Thus, in (a) and (b) the purpose was to emphasise the halo like effects on the highlights that usually happen with diffusion filters such as a Tiffen Pro Mist 3 filter when slightly over exposed, in this case using a 100mm macro lens; f/8 at ¹/₆₀ second on Kodachrome 25 film. Following the one third under/over exposure approach will often yield images whose exposure is quite acceptable making them essentially 'in-camera dupes' (all photos by Joseph Meehan).

is involved is a matter of personal interpretation, which can only be answered ultimately by having the same top-quality negative printed as a machine and hand made print by a professional lab and mini-lab respectively.

As with colour print films, the best black and white films for close-up run from ISO 25-100 and the best prints come from a skilled darkroom worker who hand prints each picture. The maximum size for exhibition quality from 35mm is again in the 8 x 10 inch to 11 x 14 inch range. So much of the final interpretation, however, depends on how the final image is cropped, burned and dodged, that the largest acceptable size is a very individual decision. Some photographers claim 'excellent results' up to 16 x 20 inch prints, and even to 20 x 24 inch sizes with such extremely fine grain films such as Kodak's

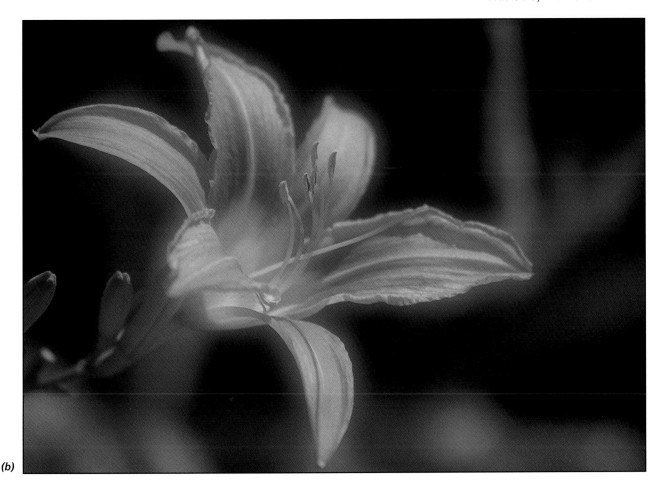

(b)

Technical Pan and Agfa's ISO 25 black and white emulsions.

While there is argument over the maximum size of a 35mm black and white print, no one disputes the fact that it is a rare black and white print that is not improved with skillful burning and dodging and that you can not expect any kind of consistent quality from machine produced black and white prints. Exhibition quality hand made prints, as with colour, can also be at least two to three times their printing costs. If you want black and white prints for your home, family and friends, a better alternative to machine prints is to contract with a friend who has a darkroom and can print reasonably well.

The question of using a transparency film as a source for prints is, as outlined above, more complicated. But there are two points over which there is no disagreement. First, a direct process print can cost almost twice the amount of a handmade C-print. The cost is even higher if a treatment known as masking has to be used in order to control contrast. Second, it is imperative that you find a good professional lab to do your printing and then work closely with them so that they know what you want. One of the keys to getting good colour prints is to be consistent in terms of the film used, the way it is exposed (as in a tendency to under or overexpose) and what type of light is favored. The more consistent

you are, the easier it is to control the whole film to print process and determine the effects of specific changes. Try to strike up a working relationship with the lab personnel and learn as much as you can from their experiences in printing your work. They will very often identify factors that you have overlooked and in the end, their input can only help you achieve better control and overall quality. Jumping around from film type to film type and lab to lab can confuse and complicate what should be a very controlled process.

Some time has been spent here on the choices in print-making because it is all too common to see photographers fail to make the right choices in this final step. There is no question that sending your negatives or slides to a professional lab is going to cost more, but let's keep everything in perspective. If you are interested in the highest quality in the final image, it is going to cost. Consider also, the expense you went to in the first place to buy the right close-up equipment and the film and processing; then all the time and effort that went into getting the shot. The only indication of your success is going to be that print at an exhibition, in your portfolio or on the wall in your home. It makes little sense not to maintain all that quality that you worked so hard to get in the first part of the process. Settling for a poor print negates all the extra efforts and money that led to the image in the first place.

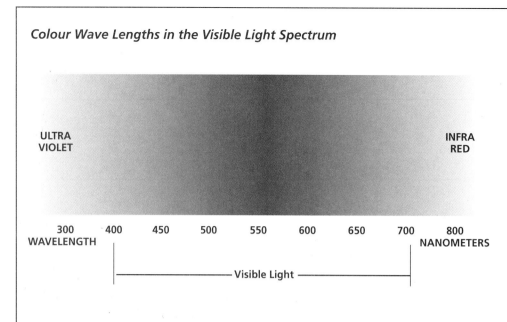

Colour Wave Lengths in the Visible Light Spectrum

ULTRA VIOLET

INFRA RED

300 WAVELENGTH 400 450 500 550 600 650 700 800 NANOMETERS

Visible Light

The so-called 'white Light' or visible light spectrum consists of wavelengths of colours rated in terms of nanometers. The cooler colours have lower numbers while the warmer colours have higher values with green in between. It is possible to significantly change the colour content of white light by using coloured photographic filters to block several of the colours. The stronger the filter (that is, the denser the colour), the more colour is blocked.

Figure 1

Colour Conversion and Colour Balancing Filters and the Kelvin Scale

Filters are among the most useful photographic tools that any photographer can have in his or her camera bag. This is true for close-up photography as well, though many close-up photographers, including some professionals, do not fully exploit their potential. All filter use is based on four logical principles. (1) That the light sources used to take photographs contain the wavelengths of all the visible colours; (2) that a coloured filter will transmit wavelengths of its own colour and block some or all of the other colours depending on its density; (3) that most non-coloured filters such as a polariser or a soft focus filter change the way light rays are recorded on film without affecting the colour content of the light; and (4) since coloured filters and a few of the non-colour filters achieve their effects by blocking some light, there will have to be compensation through an increase in exposure when they are used. This is the so-called 'Filter Factor' in which the need for increased exposure for each filter is indicated by a numerical notation such as 2x or 4x. If a 2x notation indicates a need to increase exposure by one stop, then every doubling of the filter factor indicates a need to open up the equivalent of one more stop of exposure.

In the diagram showing the breakdown of the colours in the visible spectrum of light in figure 1, the various colours have certain wavelength values indicated in nanometers. For example, red is in the 650-700 nanometer range, while blue falls between 450-500 nanometers. As photographers, we know from first-hand experience that the actual amount of these colours in natural light will vary significantly depending on the time of day, the time of the year

and the location of the subject. This is particularly true for those colours at the warmer and cooler ends of the spectrum. At sunset, for example, there is an overabundance of warm colours while in mid-day light we can detect large amounts of blue in the shade areas of a scene, such as in shadows on snow. Because colour films do not adjust to these differences in the colour content of light, their pigments will respond accordingly, and there are colour shifts or colour casts unless filters are used to re-establish a colour balance in the picture. The easiest way to deal with this need to match up the colour balance of film and light is to think in terms of the Kelvin Temperature scale of a light source as shown in figure 2.

The guiding principle and chief use of this scale for the photographer is that light sources with a higher Kelvin temperature will have more blue in their spectrum while lower Kelvin temperature sources will have a warmer red bias. A match in colour balance between a light source and film occurs when the Kelvin rating of both are the same. Among colour films, specifically transparency emulsions, there are three Kelvin ratings available; the 'Daylight Type' rated at 5600° Kelvin, and two 'Tungsten' films; 3400° Kelvin or 'Type A' film and 3200° Kelvin or 'Type B' film. Virtually all colour negative film sold today is daylight rated because the colour shifts caused by a mismatch of film and light sources can be filtered out, to a large degree, during the printing process. But even here, if the mismatch is large, as in using a 5600° Kelvin daylight film under the 3200° Kelvin temperatures of typical copy stand lighting, the results will show some colour shift.

The preferable way to be assured of a colour balance between film and light, even with colour negative film, is to use film balanced for light source

Rating Common Light Sources According to their Kelvin Temperature

Source	Degrees (in °K)	Approximate Percentage (Selected)		
		Blue	Green	Red
Clear blue sky	10,000-15,000			
Overcast sky	6000-8000	39	34	27
Sunlight, noon, high altitude	6500			
Sunlight average (4 hours after sunrise and before sunset)	5400-6000			
Electronic flash (studio)	5400-5600	33	33	33
On-camera flash	5400-6000			
Daylight blue floodlamps	4800			
Studio photofloods	3400			
Studio tungsten bulbs	3200 or 3400	20	30	50
Studio quartz bulbs	3200 or 3400			
Household lighting	2500-3000			
200 watt bulb	2980			
100 watt bulb	2900	7	32	61
75 watt bulb	2820			
60 watt bulb	2800			
40 watt bulb	2650			
Single candle	1200-1500			

Light sources will vary in their colour content, particularly as regards the amount of cooler (blue) and warmer (red) wavelengths. The Kelvin temperature rating for a light source indicates whether there is more blue (a high Kelvin temperature) or more red (a lower Kelvin temperature) present in the light. Photographic filters can be used to change these differences by blocking the excessive amounts of cooler or warming wavelengths.

Figure 2

in terms of Kelvin temperature as shown in figure 3. If that is not possible, then a filter should be used to establish a correct match up. If Daylight transparency film is to be used, for example, with the 3200° Kelvin lights of a copy stand, a blue 80A 'colour conversion filter' on the camera will shift the temperature of the copy stand lighting to 5600° K. Conversion filters are a class of filters designed to make the large changes in the colour content of light possible to allow the use of a film balanced for one light source to be used with another (see figure 3).

Tungsten film can also be balanced for daylight by the use of an 85B orange filter which will boost the proportion of warmer colours allowed through. This is because there is a limited representation of warm colours in the tungsten film in the first place to offset the inordinate amount of warm colours present in tungsten light as shown in figure 2. Logically then, just the opposite set of conditions prevailed then when the 80A colour conversion filter was used with the daylight film. Since, the tungsten light is high in the warmer colours, the blue filter allows all of the lower amounts of blue available to come through while holding back much of the warm colours.

While it is always preferable to use the right film with the right source that does mean often times having to commit a camera body to a 3200° Kelvin emulsion film. Consequently, many photographers will use a conversion filter with the far more common daylight colour print films when working under the tungsten lights of the copy stand or table top studio. The one disadvantage of doing this, as mentioned earlier, is that using conversion filters significantly reduces the amount of light transmitted to the film as part of the conversion process, necessitating an increase in exposure. This may not prove to be much

Selecting the Appropriate Combination of Film and Light Source

Colour Film Type	Balanced for*	Filter Required		
		Daylight	Photo Lamp (3400K)	Tungsten (3200K)
Daylight	Daylight, blue flash, electronic flash	No filter	80B	80A
Type A (3400K)	Photo Lamps (3400K)	85	No filter	82A
Type B (3200K)	Tungsten (3200K)	85B	81A	No filter

The correct colour balance between film and light source occurs when the Kelvin rating of the film and the light source are the same.

Most copy stands are equipped with 3200° Kelvin Quartz-Halogen lighting. Slide duplicators are frequently equipped with flash as the light source.

Figure 3

of a problem, since few moving subjects are photographed under this type of lighting and therefore, slow shutter speeds can be used. While there are fewer tungsten rated colour reversal films available than daylight emulsions, there are enough to fill most needs, with speeds from ISO 40 to ISO 640 and it is probably fair to say that most photographers using tungsten lighting use a tungsten-balanced film.

As far as monochrome films are concerned, these do not, of course, reflect any mismatches in colour balance. Some are, however, less sensitive to tungsten, and the photographer should consult the film data sheet to see if a slight adjustment is necessary when working under tungsten lighting. This usually amounts to the need to increase exposures by about one half to two thirds of a stops which is done in a very practical way by rating the film at a slightly lower ISO.

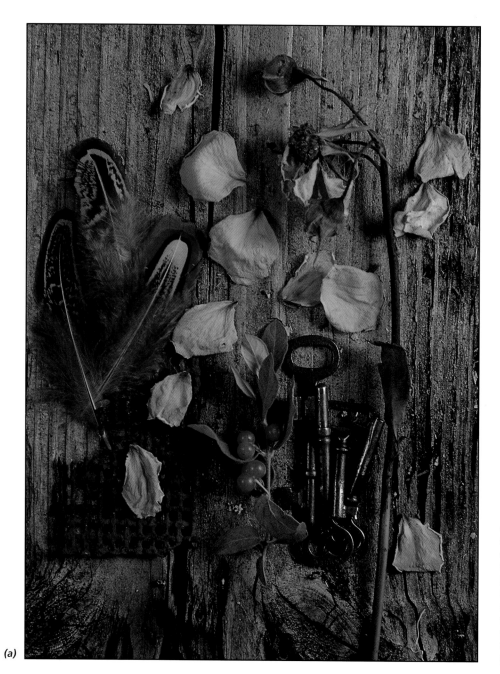

(a)

A comparison of the differences between the way a colour transparency and a colour print reproduce in a publication can be seen here in Joseph DeGeorge's still life. (a) is the original Velvia transparency and (b) a colour print produced from a 4 x 5 inch inter-negative of that transparency.

Even when an attempt has been made to match the colour temperatures of film and light, there may still be reason to use filters to alter the Kelvin temperature. This is because daylight varies so much in terms of colour temperature that it is often necessary to use filters to make changes of just a few hundred degrees Kelvin in the light. When smaller changes are required, a second class of filters called 'colour balancing filters' (or as they are more commonly known, warming and cooling filters) are employed. Specifically, these are the amber coloured 81 series warming filters or the light blue 82 series cooling filters. In the case of colour print films, the small changes caused by the use of these filters could be added during printing and, in fact, if you do not instruct your printer that these filters have been used, he or she will filter out the effects as part of the

process of delivering a neutral, colour correct print.

Since much of close-up photography out of doors is done in shade or under indirect sunlight, there is more of a need to use the warming 81 filters to reduce the excessive blue that characteristically is part of these settings. The most commonly used warming filter in this regard is the 81A and to a lesser degree, the 81B and 81C, each of which lower the Kelvin temperature of a light source by increments of about 200° Kelvin. There is no set rule as to when or which of these filters should be employed and in fact, many photographers will use a warming filter beyond its ability to balance the Kelvin temperature because they like the warm effect itself. Furthermore, the type of transparency film being used may also influence the use of these filters. For example, Velvia is an emulsion that already has a warmer rendering of colours, as are

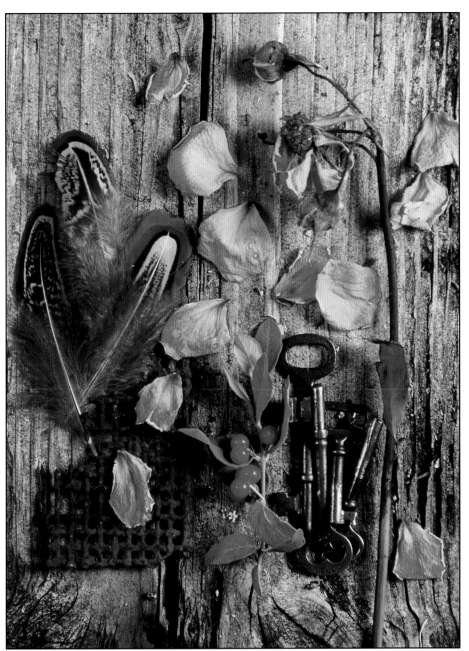

(b)

that already has a warmer rendering of colours, as are the 'X' emulsions from Kodak. Consequently, there may only be a need for the weaker 81A filter, if any filter at all. Again, it is a matter of interpretation and personal testing is the only way to determine the significance of the effect. Exposure compensation for warming and cooling filters is generally under one stop.

The popular 1A or skylight filter, which has a slightly 'pinkish' cast, is an example of a very weak warming filter requiring no exposure compensation. It also blocks some of the ultraviolet radiation that tends to be present in shady areas that registers as blue in the image. This filter is a good alternative for those cases where a warm film is already in use and there is a need to hold down some of the UV radiation while adding just the slightest warmth.

Using a cooling filter is generally confined to those less common occurrences when there is too much 'warm light' and the photographer wants a more neutral rendering. Again, the same principle holds in which there are specific increments of Kelvin change, only this time the temperature increases because the warmer wave lengths are being blocked.

Colour Compensating Filters

There is a class of filters called the Colour Compensating or CC filters which are used to make very specific corrections in the colours of light other then just the warming and cooling. That is, these filters come in the six primary and secondary colours of red, green blue, magenta, cyan and yellow. They are available in various strengths or densities from as

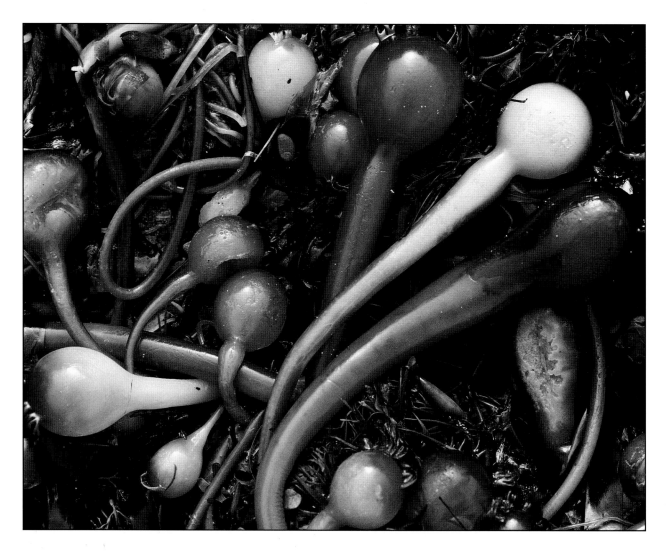

Another way of controlling extremes of brightness in a scene is to use a polarizing filter to reduce glare from shiny objects as was done on this mass of Air Bladder

Kelp photographed by the author on a bright, hazy day with a 100mm macro lens at f/8, $^1/_{60}$ second using T-Max 100 film.

little as .25 which is just noticeable to the human eye, up to a full colour rendering of 1.00 density. These filters can be added together and, like the warming and cooling series, they do require some small exposure compensation. CC filters actually include the equivalents of the warming and cooling series. For example, an 81A filter is a combination of .90 cyan and .30 magenta. It is, however, more common to purchase a specific colour balancing filter such as an 81A than to make one up from a combination of CC filters which are most commonly available in their complete range as gels rather than the more practical threaded glass design.

The value of the CC filters, much overlooked by close-up photographers, is their ability to increase the saturation of a colour when it is being photographed under low contrast conditions. For example, by using a CC20G (green compensating filter in a density of .20) proportionally more green light comes through to make the subject appear much greener. The problem is that the appearance of other colours, particularly white, may change. That is because the filter is blocking, to some degree, all other colours and allowing only green to come through. For example, the white light bouncing off a white flower, has all of

its colours blocked to some degree to allow more green to come through. When the density of the filter becomes strong enough, a green cast will be detectable in the white flower and will become more pronounced as stronger filters are used.

The best application then is to consider using a CC filter when a particular colour dominates as in a shot of green leaves. A CC filter can also be used in a mixed-colour setting in a low enough density (typically .10 to .20 densities) so that the filter's colour is boosted but the blockage of other colours is not enough to change them. In general, white is the most susceptible to showing a colour cast, while strong single colours are the most resistant. Since close-up photographers working in the field are far more likely to come across all-green subjects, CC green filters in either .10, .20, or even .30 densities are a good choice to take along all the time. Another possibility is to use a filter that is associated with black and white

Shown here are (top row, left to right) the warming filters, 81C, 81B, 81A and an 85B orange conversion filter. The relatively weak colours of the three warming filters account for their more subtle effect as compared to the denser conversion filter. The same comment can apply to the cooling filters (bottom row, left to right) 82C, 82B, 82A and the 80A conversion filter. (Close up on 3200° Kelvin rated light table with Kodak Tungsten Type a 64T film, 60mm macro lens by Joseph Meehan)

Filters normally used with monochrome films are generally dense since they have to make enough of an exposure difference to shift the tones of a black and white print. Shown here are the most common coloured 'monochrome' filters (Same photographic set up as the conversion, warming and cooling and conversion filters by Joseph Meehan).

Colour Compensating (or CC) filters are available most widely as gel filters in Red, Green, Blue, Yellow, Magenta and Cyan. They are available in as weak a density as .25 to a strong 1.00 as shown here for yellow and are used primarily to make slight adjustments in the way a particular combination of light and film record colour. They can also be used to 'boast' a particular colour under certain circumstances (Same photographic set up as the conversion, warming and cooling and conversion photo).

(a)

A mismatch in the rated colour balance between a film and light source is seen here in this macro close-up of a detail on a British 20 pound note by the author. In (a) Tungsten film type B (Kodak 64T rated at 3200° Kelvin) was used on a copy stand with 3200° Kelvin quartz lights for a colour correct rendering of the subject while (b) shows the effects of using a daylight balanced film (Kodak Ektachrome 64) under the same conditions. (Both photos by Joseph Meehan using a 55mm macro lens and extension bellows at approximately 1:2).

photography, the Yellow-Green or G11 filter which is similar in its effect in this regard to the CC30G. There is also a special type of filter called an 'enhancing' or 'Didymium filter' which has a more general effect in boosting the warm colours and greens and can serve to brighten a scene dominated by these colours in any light. For example, this filter has some very dramatic effects on the warm leaf colours typical of autumn.

The second most useful CC filter for close-up work is a Yellow in .10 and .20 densities. Again, you have to be careful of the effects on white, but when working with yellow flowers in flat light against green foliage, this filter can make a real difference. Finally, a CC10 or CC20 Red and Blue are very effective for

boosting their colours in blossoms in deep shadow. The Red filter is particularly effective in boosting the reddish tint of rusting metal from its all to often brown appearance

Filters for Black and White Films

A special set of stronger coloured filters are commonly used with black and white films to change the tonal arrangement of a scene. These filters are based on altering the amount of light coming from various colours in order to change their tonal value in the final print. The translation of colours into shades of gray in black and white photography is based on how much

(b)

CC filters work best when a scene is completely dominated by their colour or very dark colours including black. In (a) and (b) we see the before/after effects on the plant of a CC .40 Green filter while in (c) and (d) the before/after effects of a CC .30 Red filter to enrich the colour of the main subject. Both of these effects represent the use of the strongest types of filtration; weaker filters such as a .10 or .20 give more subtle effects which may be preferred by some photographers. (Photos by Joseph Meehan using a 105mm macro lens; the CC green filter was used with Kodachrome 64 film and the CC Red with Agfachrome 50).

(a)

(b)

(c)

(d)

(a)

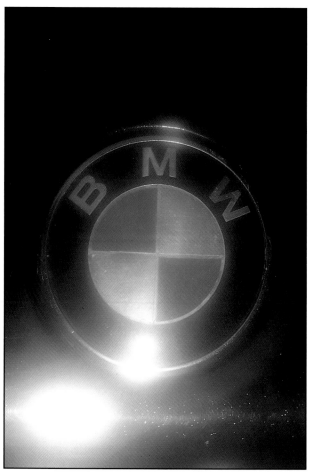

(b)

light that particular colour reflects toward the camera. Thus, light yellow reflects more light (because it absorbs less) than a dark blue subject, which reflects far less then it absorbs. The so-called black and white filters which include, the Red 23 0r 25, the Green 58, the Yellow 11 and Blue 47, are especially useful to the nature close-up photographer, since the chief colours encountered often translate into similar shades of gray in a monochrome print. For example, green foliage translates as a dark shade of gray, as do many smaller subjects such as brown bark or even red flowers. It is often a great help if these colours could be separated out by having some recorded as lighter in order to set them apart tonally from dark backgrounds. This can be done because the same filter principles used for colour film also apply to black and white film. That is, to lighten a particular colour, use a filter of the same colour.

Thus, the coloured filter lets proportionally more of its colour through to strike the film. In the case of a negative monochrome emulsion, this would cause that area on the film to be more exposed and therefore more dense after development. When this negative is printed, this denser area holds back more light, producing a lighter result in the print. There is also a secondary effect in that the complementary colour to the filter being used undergoes the opposite effect: it is strongly blocked, causing that area of the

A soft rendering of close-up images, especially in the case of shiny subjects, can change dramatically with the use of filters of different strength as seen here with a Tiffen Pro Mist 4 filter before (a) and after (b) (hand held 105mm macro *shot by the author at f/5.6, $1/_{250}$ second on Agfachrome 50 film). For a more subtle rendering with a weaker version of this Tiffen filter see the effect on the Daffodils earlier in this chapter, as well as (c) opposite.*

negative to receive much less exposure, thus appearing much darker in the print. For example, using a green filter to lighten the green leaves of a plant will darken its red blossom because red is the near-complementary colour to green. Figure 4 contains a summary of the most useful filters in close-up work and the most appropriate subjects with which they can be used.

Polariser and Soft Focus Filters

Polarising filters have an application in close-up photography because of their ability to eliminate glare from shiny surfaces. These filters are widely used in general photography for that purpose, as well as to darken blue skies or, in the case of black and white prints, make skies appear darker gray or even black. The problem with glare, is that its intensity is much brighter then the diffused light that contains the colours of the subject. The result is that a reflection

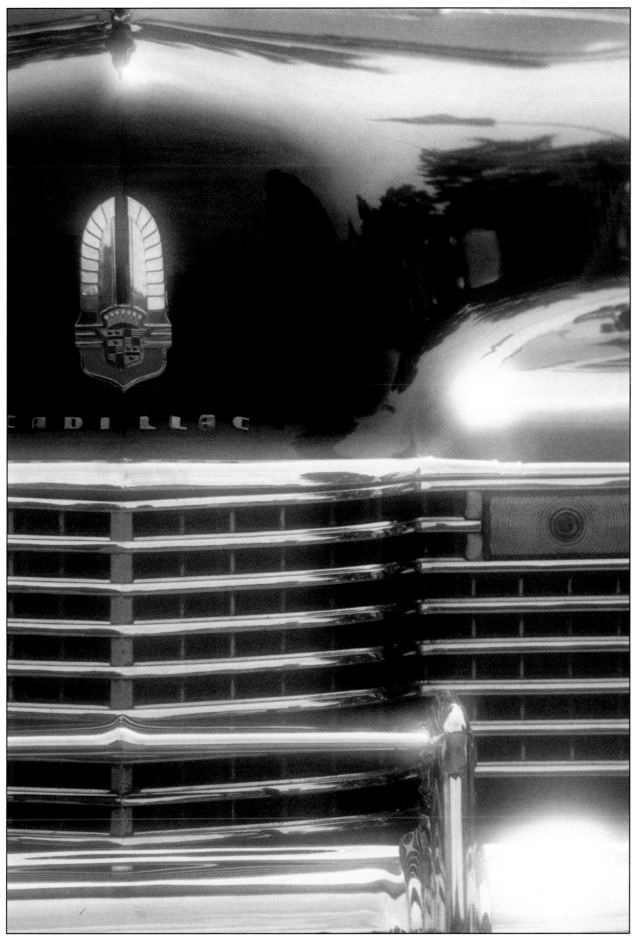

(c)

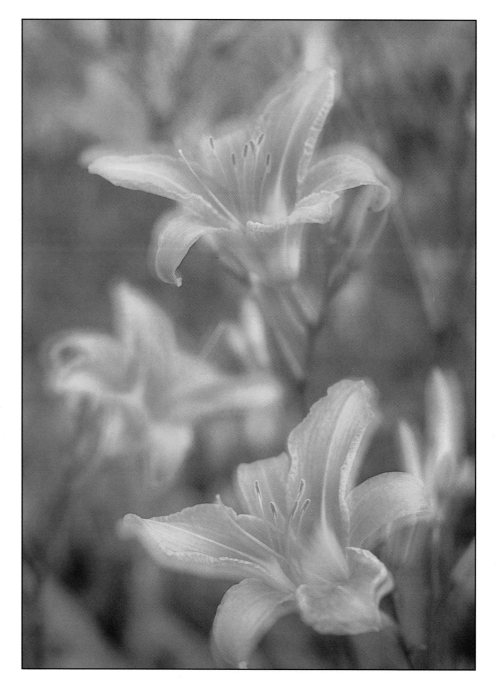

Art Gingert used a different technique based on a double exposure to produce this soft effect with a Day Lily. The first exposure was taken in sharp focus and was followed by a second exposure in which the subject was defocused slightly.

overwhelms this weaker light and dominates the area in which it occurs, overexposing the film beyond its latitude. What a polariser does is to set up a screen that blocks the glare light that is concentrated in this small angle of reflectance. This, of course, also eliminates the small amount of diffused light that is within that specific angle, but it also now permits the diffused light coming from all other angles to be recorded. The result is the elimination of the glare light and a richer rendering of the subject's chromatic makeup (without the glare light to interfere) along with a need to increase exposure a stop or slightly more to offset the light blocked by the filter.

There are times when a polariser will not work on glare as in the case of shiny unpainted metal objects. Some photographers have a rule of thumb that if a

shiny subject can conduct electricity across its unpainted surface, then it will produce a type of reflection that cannot be blocked by a polariser. Glare is a common problem on the copy stand when very glossy pages of a book cannot be made to lie flat, causing a pronounced glare that is only partially blocked by a polariser. Here, there is a need to also place polarizing filter material over the light source in order to virtually eliminate the reflections.

Soft focus or diffusion filters as they are also called, may seem, at first, to be contradictory to the very nature of capturing close-up subjects in sharply defined forms and fine detail. But there are certain cases in which you might find their applications appealing. This is when diffusion filters with a pronounced flare component are used in strong

sunlight. Traditionally, soft focus filters are used to 'soften' unwanted details such as facial blemishes in a portrait. But certain filters will produce a strong halo of flare around areas of bright reflection sometimes called halo-effect. To test for such an effect, just hold the filter up to a reflection off a shiny surface such as from the bright metal work of an automobile and you will see the halo effect. A very interesting mood effect can be created by combining a halo diffusion filter with a strong warming filter such as an 81C for a unique, very warm soft focus rendering.

There are a number of other so-called special effect filters some close-up photographers like to use. One is the center spot filter in which the middle portion of the filter is clear, providing a sharp image, while the other portions are softened by irregularities on the surface causing the outer areas of the image to appear soft. A split close-up filter is essentially a half frame close-up filter of +1 or +2 strength that enables the photographer to position an object close to the lens and have the upper half of the frame in focus even though it is beyond the depth of field of the f/stop being used. Other examples of special effect filters include star-effects, multi-image designs that repeat an image, and 'speed streak' filter that blur half of the field in such a way as to give the impression of a speeding object.

Filter Recommendations for Close-Up Photography

Filter	Purpose
81A	General warming filter frequently used in deep shade settings. An alternate filter with less of a warming effect is the skylight or 1A.
11 Yellow/ Green	With monochrome films in copy work, will remove yellow and brown stains on old pictures as well as increase contrast in yellow faded prints. Will eliminate the blue lines of graph paper
CC Green CC Red CC Yellow	These filters will generally boast their own colour without affecting other colours when used in .10 to .30 densities.
Polariser	Use to remove glare from shiny surfaces; to see through the surface glare of water as in shooting into tidal pools and to darken blue skies in low angle close-ups.
25 Red 58 Green 47 Blue 11 Yellow/ Green	These filters are used with monochrome films to lighten their own colours and darken those that are complementary. They also can be used to change the appearance of wood surfaces as follows: use the 25 or 11 to lighten cherry, mahogany or darker walnut finishes; to darken these woods use a 58.
Soft Focus/ Diffusion	For slightly softer rendering try Tiffen's Soft FX series and Pro Mist series #2 or Nikon's Soft I. To obtain a 'Halo' around strong highlight areas use the Pro Mist #4 or #5.

Figure 4

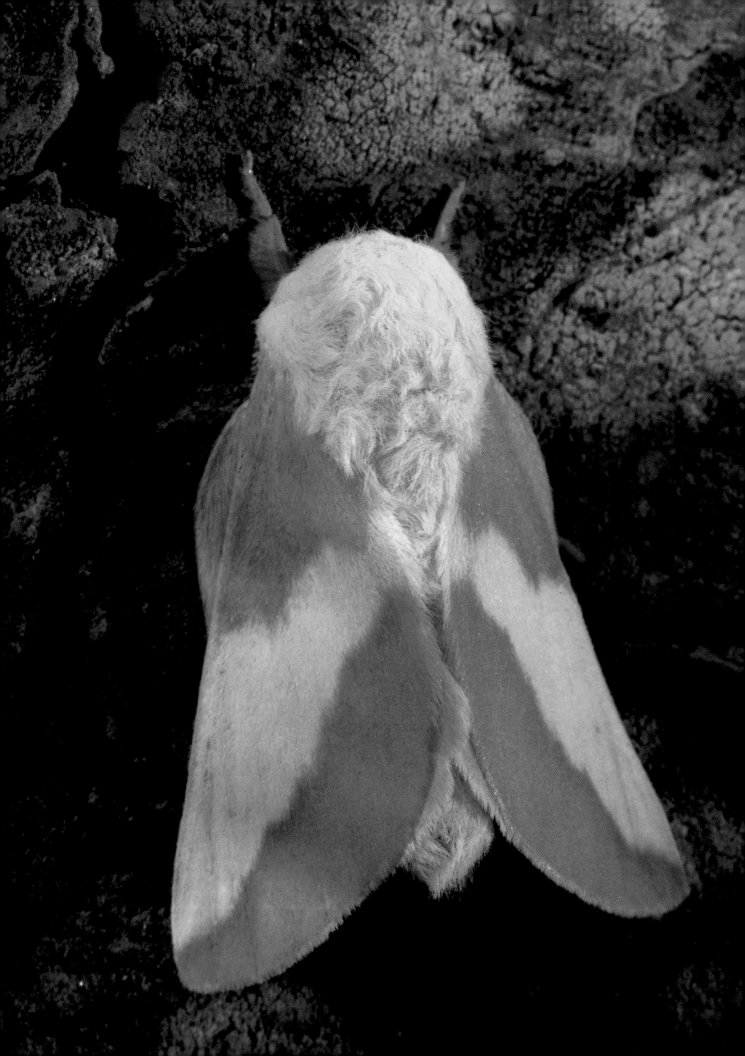

LIGHTING OPTIONS & EXPOSURE METHODS

The ability to take properly exposed and effectively composed photographs under appropriate lighting in order to give a distinctive interpretation to a subject is a good part of what photography is about. The specialty of close-up photography certainly follows this generalisation. But, as we have seen with exposure, depth of field, and composition, close-up photography does change some of the rules and therefore, the conditions under which a photograph is made. That extends to the way light is used to portray the subject, and how the photographer makes decisions about the question of proper exposure.

What concerns us then, in this final chapter, is that a versatile close-up photographer needs to be able to work under a wide range of lighting conditions, using a variety of light sources. To do so effectively requires a broad understanding of light per se and the way various subjects respond to it. Having a solid understanding of the qualities and behaviour of light also means being able to think about exposure more as a critical concept in photography rather then as a procedure largely carried out by the camera's meter. In this final chapter then, we will also be providing some specific exposure methods for use with with close-up equipment.

Photographic Lighting

A photographer who works with a wide range of close-up subject matter will encounter all of the major types of lighting that any other photographer does. For example, in addition to dealing with every manner of natural light from bright sun to haze and overcast, most close-up photographers will also use flash as part of their work in the field. In addition, many work indoors using either a small off-camera flash or tungsten light in table top situations. So on a busy day, a well-rounded photographer might shoot some general close-ups of good-sized flowers in an open sunlit field alternated with wider shots of tiny flowers occurring as sprays in deep shade and then a close-up of the weathered side of an old barn lit from the side

by direct sunlight causing a dramatic rendering of its texture. Later that afternoon, there may be the need to use flash to catch bees taking pollen from inside a flower; then in the early evening, working indoors on a table top studio shooting small items of value for documentation purposes such as jewelry or porcelain, with a small diffused flash. The day is finished off working on a copy stand shooting pictures under tungsten lighting to be used in a lecture. Thus, a versatile close-up photographer must be able to work with every kind of photographic light under a wide variety of conditions.

All of us have a lifetime of experiences with natural and artificial light sources, but not with what might be termed 'photographic light;' that is, those lighting situations that provide the type of illumination that is particularly appropriate to record a subject on film. It is only since we began to take pictures seriously that we became concerned with such things as whether or not there is enough light (intensity of the source); if the light comes from the right direction to allow us to capture the whole range of illumination (contrast of the subject); if the film being used is capable of recording the extremes of brightness in the scene (latitude of the film); and if there will be the right colour rendering (colour correctness between source and film) in the final transparency or print. So while we may have a lifelong experience with light it is necessary to organise what we know into photographic conditions.

There are a number of ways of developing this 'photographic mind set' about light and its effects. One is to think about the qualities of light that control its photographic effect. This is done in conjunction with considering those characteristics of the subject that show the effects of these qualities. In the case of light, there are three specific attributes that play a dominant role: (1) the size of the source relative to the size of the subject; (2) the direction of the source relative to the subject and camera; and (3) the role of secondary reflecting surfaces. As far as the subject, the most important things are (1) the texture of its

surface; (2) the colour or colours that dominate and (3) its form in relation to the size and direction of the light source.

As far as how light forms and shapes the appearance of the subject, photographers generally talk about light in terms of the areas of illumination it produces in a picture. That is, the appearance of the highlights, shadows, and middle tones. Since we are concerned here with the effect of light in close-up photography, we will begin by looking at these three areas of illumination first, and relate that information back to the qualities of light.

Highlights, Shadows and Middle Tones

Every photograph, whether colour or black and white, has three main areas of illumination, with several subdivisions in which information about the subject and scene are recorded on film. The main areas are the 'highlights' or brightest parts of the picture showing different tones and details; the 'shadow areas' or darkest portions showing different tones and details; and the 'mid-tones' covering everything in between. In the most basic of terms, these areas appear as they do because light is either absorbed or reflected to a certain degree and in a particular way by the subject. Thus, the final image on film is a 'light picture' of the subject resulting from the myriad ways that individual light rays are absorbed and reflected

The key to making decisions concerning correct exposure is to understand how the areas of illumination in a scene are divided up into highlights, middle tones and shadow areas. In copy stand work there is rarely a problem capturing these areas for a typical subject because of the even lighting and flat nature of the subject. The usual procedure is to take readings from a gray card and set the camera in its manual mode to these readings. Results such as shown above can be expected on a predictable basis.

Similarly, scenes that are predominately made up of middle tone values as in Jeff Lapore's close-up of Jack-o-Lantern gills opposite can easily be read.

off the subject.

When light hits a surface, it reflects in a very specific way following the principle that 'the angle of incidence (the angle at which it strikes the subject) is equal to the angle of reflectance (the angle at which it bounces off the subject's surface)'. We know from our discussion of filters that, in addition, some of the coloured wavelengths of light will be absorbed by coloured objects. Moreover, black will absorb most if not all the light, and white will absorb very little, reflecting most of what falls on its surface. Also, a smooth surface appears shiny because the light is reflected in a concentrated manner and in the same direction. In the case of very smooth surfaces, the result is glare, which can be bright enough to appear like a separate light source. On the other hand,

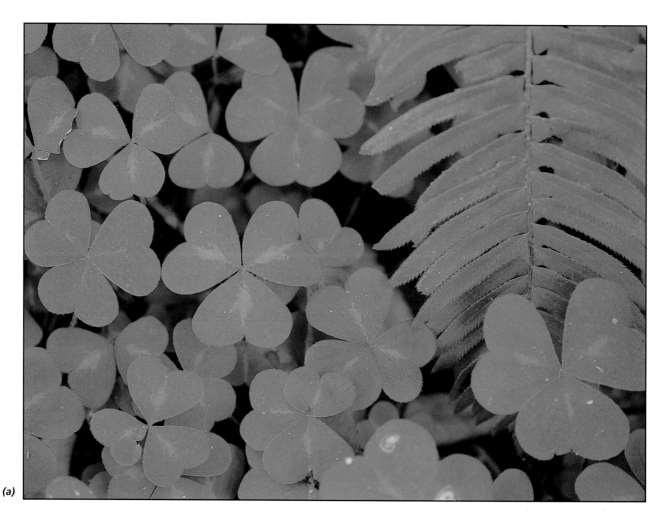

(a)

irregular surfaces send their light off in many directions producing a diffused effect negating the formation of glare and making the surface texture appear soft. For example, the smooth leaf of a Rubber plant versus the velvet surface of a violet's blossom. The results of all these different treatments of light by the subject's colour and surface texture then, are the three areas of illumination.

In a typical scene, 'highlights' are the brightest sections that receive the highest intensity of light and give off the most light as a result of their surface texture, colour or both. For example, the light pink petals of an orchid in sunlight or the bright yellow painted metal body of a toy car under studio lights reflect a very high proportion of the light that falls on them, but not as much as the white page of a book on a copy stand. When correctly recorded on film, these areas will show the details of their makeup by displaying slight variations in texture, colour or both. Brighter areas than this, such as reflections from the unpainted metal portions of a polished tool or the glare from a broad leaf's shiny surface in sunlight, would be considered beyond the highlight detail areas and are referred to as 'specular highlights.' Such examples are recorded on film as pure white or with a very weak colour cast, and always without detail. Furthermore, the reason the petals and book page

appear soft and the fender smooth is determined by surface texture of these subjects.

At the opposite end of this scale of brightness are the 'shadow detail areas' containing the darkest portions of the scene which absorb the most light and receive a far lesser amount of light, but in which details are still discernible in the on-film image. For example, the veins of a dark brown leaf in deep shade or the lettering on the door of a miniature toy truck in the shadow caused by another toy car. Beyond this are the 'pure shadow areas,' which have no details or tones and appear as a solid dark colour or more commonly as black. Characteristically, pure shadow areas are not associated with being illuminated, directly or indirectly, as in a hole in a tree or the area under a toy car in shade.

In-between the highlights and shadow detail areas are the 'mid-tones,' which are the heart of any photograph in the sense that they are made up of the truest colours (or fullest range of tones in a black and white print) that are in the scene. This is because the light captured on film here is either not as strong as it is in the highlight areas or not as weak as in the shadow sections, and the nature of mid-tone subjects falls between that of highlight and shadow subject matter. This portion can be quite diverse in the amount of reflected values as, for example, from the

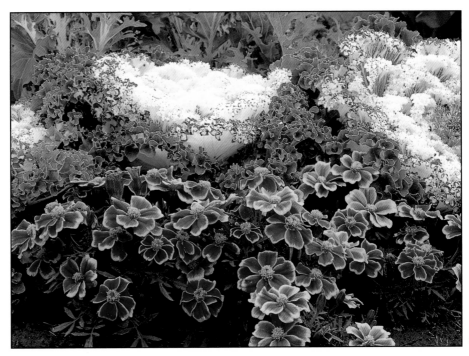

(b)

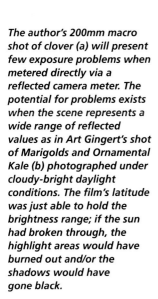

The author's 200mm macro shot of clover (a) will present few exposure problems when metered directly via a reflected camera meter. The potential for problems exists when the scene represents a wide range of reflected values as in Art Gingert's shot of Marigolds and Ornamental Kale (b) photographed under cloudy-bright daylight conditions. The film's latitude was just able to hold the brightness range; if the sun had broken through, the highlight areas would have burned out and/or the shadows would have gone black.

brighter mid-tone colours of a red rose in sunlight down to that same red flower found in those areas of the scene that are just out of the direct rays of sunlight in open but still very bright shade.

This characteristic larger range of values associated with the mid-tone area as compared to the highlight and shadow portions is the main reason this section is so valuable photographically. It is, for example, where we look for the most accurate representation of our subject in terms of colour, and where to find the subtleties and refinements of details that will tell so much about the subject's structure. Take, for example, a macro close-up of a maple leaf turning various colours and drying out as part of its autumn cycle. Such a subject in medium light can be made up almost entirely of mid-tones and yet seem to convey a feeling of full contrast by virtue of the wide range of mid-tone colour hues. A full range of high, medium and low values within the mid-tone area can thus substitute for missing shadow and highlight areas, which are the usual reference point for contrast since they represent the extremes of reflectance in a scene. In close-up work where many compositions are dominated by tight shots of a subject's mid-tones, correctly recording this area is paramount but fortunately easier then with a scene of extremes in contrast.

As a matter of convention, the term 'highlight' generally refers to only the brightest areas with detail and not the specular areas just as the term 'shadow' includes the darkest areas with detail but not the pure shadows. A reference to 'mid-tone' includes the entire range between shadows and highlights and we are using the abbreviation 'HMS' to refer collectively to these three areas that collectively contain all the details of visual information about a scene.

Contrast and Film Latitude

The difference in illumination (which can be measured by a light meter) between the highlight and shadow areas (with details) represents the contrast range of a scene, and relates to the film's latitude as expressed in f/stops. That is to say, the difference in total stops between the high and low values in a scene will indicate how much of a scene will be captured on film. Thus, for colour transparency film, a difference of more than three stops between highlight and shadow areas will cause highlights and shadows to lose whatever details they have on film. If the brightest highlights in which detail is desired is more than three stops from the darkest shadow detail area, and the exposure is set for exactly halfway between them, the result will be some washed out highlights and loss of details in the shadows. This is where using light modifiers such as diffusers and reflectors comes into play either to reduce the intensity of light hitting the highlight areas or to put more light into the shadow areas allowing one or both to be recorded (with details intact) within the film's latitude.

The size of the light source illuminating a subject and its direction relative to the subject and camera will have a profound effect on not only the contrast range but the appearance of the HMS areas themselves. For example, a small and very directional light source such as an on-camera flash or the sun on a clear day, produces a 'hard look' when compared to larger light sources. This is because these small light forms hit the subject from a very narrow source point producing the higher levels of intensity in the highlight areas while casting large and pronounced shadow areas behind the subject. The narrow angle also causes much more sharply delineated borders between the highlights,

The best arrangement for copy work is a copy stand as shown above. These usually come equipped with a set of tungsten or quartz lights balanced for 3200° Kelvin which can be set at a 45° angle to the based board to minimise glare. The upright mount keeps the camera solid and the film plane of the camera parallel to the baseboard. Most commercial copy stands can be used for moderate, macro and extreme close-ups.

A temporary copy stand can be arranged by using a tripod aimed at a wall on which the art work has been taped, with lights on light stands set at either side at a 45° angle to the wall. This works well for moderate close-ups but the legs of the tripod hitting up against the wall will usually prevent the camera from being positioned close enough to do macro close-ups.

A table top studio can be configured so that the camera is brought over the top with lighting arranged at the 45° angle as shown above. This is works best for macro and extreme close-ups.

No matter which copy stand arrangement is used, the procedure for doing copy work is the same.

1. Always be sure that the camera's film plane is level to the plane of the subject. An inexpensive bubble level mounted in the hot shoe of the camera can help determine that the camera has been mounted correctly.

2. Once the picture is composed and the lens focused, place a gray card large enough to fill the entire field on the baseboard and set the camera's exposure controls accordingly using an f/stop setting between two and three stops below the lens' maximum aperture.

3. Lock this reading into the camera and do not change these manual settings as long as the camera-to-subject distance is not changed. Do not place the camera on automatic as the readings will change with each change in subject matter.

4. If a zoom lens is used, focal lengths can be changed without having to take a new meter reading. If the camera' position is changed, a new reading must be taken.

5. Be sure to use a cable release and remember that some cameras will show significantly less in the view finder that is actually recorded on film. This can be critical in a tightly cropped picture.

This Bencher wall mounted copy stand used by the author has two 3200°K Lowe Pro quartz lights set at 45° to the baseboard. Provision for polarising filter material is available through the use of plastic frame holders in front of each light.

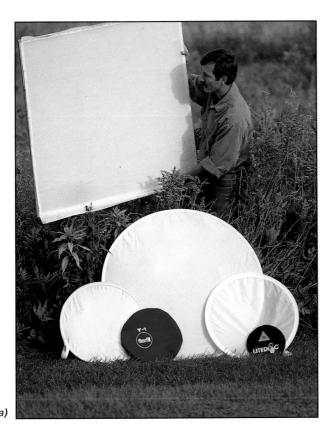

(a)

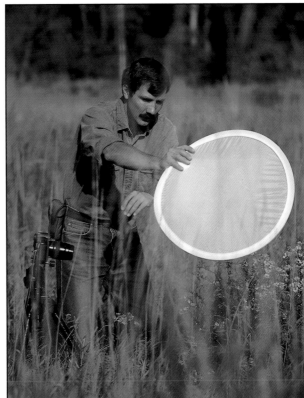

(b)

Some of the most useful accessories a field or studio photographer can have are diffuser panels which turn small, harsh light sources such as the sun or a compact flash into a medium source by scattering (diffusing) the light as it passes through the material. The degree of diffusion will depend largely on the material's density and weave as well as, to some degree, its size. Art Gingert is shown here

(a) holding a large, home-made panel that he has found to be very effective along with various examples of the foldable commercial brands of diffusers and reflectors such as Photoflex and Flexifill. In (b) Gingert demonstrates how an unfolded Photoflex diffuser panel should be positioned at a distance from the subject in order to get proper coverage (both photos by Joseph Meehan).

mid-tones and shadows. In other words, there will be an abrupt transition between bright and dark areas, giving an impression of high contrast. This is also the type of light that will most likely cause glare if the subject's surface is shiny. The reason is the concentrated nature of light from a small source point that is preserved (via the incident to reflectance principle) as virtually all the light is reflected intact and in the same direction from a surface that is essentially made up of one reflecting plane.

If the direction of the light is also at a strong angle to the subject as in side lighting, then there will be a tendency for the mid-tone area to be severely contracted as the highlight portion suddenly drops off into the strong shadows on the opposite side of the subject, adding to the high contrast impression. That is why strong angular light makes for very dramatic texture shots. It causes surface irregularities to cast the

strongest possible shadows which accent their protruding character across a flat surface as in a close-up of the raised grain of weathered wood.

The overall appearance on film of subjects shot under illumination from small light sources is then a harsh, brassy rendering with strong shadows and greater chances of specular highlights all because of the narrow angles at which the source falls on the subject. Consequently, under such light, there will be a reduced chance of recording the delicate details and subtleties of colour variation and tones a subject might possess. This may raise a question about the popular practice of using a small on-camera flash with close-up subjects. Actually, this is done most commonly with subjects in the macro or near macro range and the point is very often either to freeze a moving subject or to have light enter down into an area as in the recesses of a Morning Glory blossom. These are very small subject areas which are about the same size as the light source, and the light itself is coming straight on. The result is a very even though intensive light which will not necessarily encourage subtle details but will not produce large shadow areas either because it is evenly covering the whole subject. If this sort of light is to be used with the larger subject area of a moderate close-up, it will not cover the whole subject and shadow areas will appear. This might call for the use of some sort of flash diffuser to maintain the equality between the size of the light and the size of the subject area.

So-called medium light, where the size of the source is significantly larger, that is, at least the size of

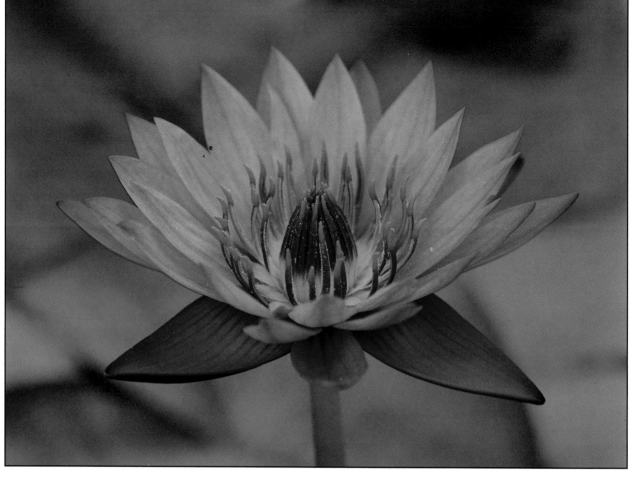

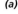

(a)

the subject, is generally considered a much more desirable light for photography in general and for close-up work in particular. This is because it permits a wider range of total visual information to be recorded on film, by making full use of all parts of the HMS range. Examples include the kind of diffused light caused by high thin clouds or a hazy day where the small size of a bright sun is greatly enlarged as its light is scattered in passing through the clouds or haze. Most often, these days are referred to as 'cloudy bright' or 'bright overcast' conditions.

This is also the type of light that is produced by studio 'soft boxes' and 'photographic umbrellas,' as well as from panels of diffusers placed in front of lights. In the case of a diffuser, the density of the material will control the size of the light source. For example, a very thin fabric with a wide weave will allow more light through in a more concentrated shape (that is, smaller form) around the area where the beam is striking the fabric. Tighter weaves and denser fabrics will scatter the light more and produce a larger shape (larger form) that can cover the subject completely. Umbrellas, on the other hand, are based on the principle of enlarging a small light source by scattering the light from reflecting it off a large surface. The larger the umbrella, the larger the light form and the softer the effect. A studio softbox

combines the reflection of its interior with diffusion through the screen across its front for a very efficient and more directional result which is why they are so favored by today's studio photographers.

Whatever the mechanism, the result of increasing the size of a light source to that of the subject's proportions or larger is the ability to 'reach around' and fill-in much of the shadow areas produced by a smaller form. Likewise, the bigger the medium source relative to the subject, the greater the intensity of the fill. This leads to more of a transition or 'feathering' of the border areas between each HMS area. Also, converting a small source to a medium form lowers the relative intensity of the light falling on the highlights and removes much of the high-contrast look of a small light source by also pulling more of the shadow areas into the latitude range of the film. Yet, at the same time, a medium source is still small enough to be placed at angles to the subject to cast major shadow areas for contrast. But again, these are softer shadows that tend to model the shape of a structure's edges rather then blacking them out. The result is to reveal more subtleties by the presence of these softer shadows rather then causing the stark, high relief textures when a smaller source is set at an angle to the surface.

The kind of light that is associated with a white

(b)

Reflectors are another valuable tool for bouncing more illumination into shadows to help match the brightness range of the illumination to the film's latitude. If enough light is used, the middle tones can also have their brightness level elevated and 'warmed' as well as by the use of gold materials. Black 'subtractive reflectors' work to increase contrast levels by blocking the illumination from one side of the subject in situations where even lighting has lowered the contrast to make things appear flat. For example, in (b) Art Gingert first photographed this Tropical

Water Lily in bright back lighting and again in (a) with a thin diffusing panel between the subject and the light source.
In the studio, the author changed the light of a silver lined umbrella in (c) which produced some strong reflections from the shiny metal surface to a tent light effect using a MacroMate front lens hood attachment (see product shot, this chapter) in (d) which toned down the presentation of the product. A small Photoflex black gobo was used to the right of the subject to hold some of the contrast.

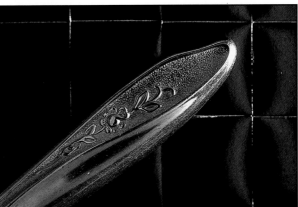

(c)

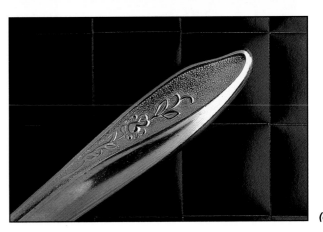

(d)

hand-held reflector is basically a medium light when the surface of the reflector is used to bounce light onto the subject. It is far weaker (which is appropriate for a small amount of fill in shadow areas) because it is placed so far from the source as explained ultimately by the Inverse Square Law (see Appendix). The efficiency of the reflector is greatly affected by its construction. A shiny silver surface reflects more light,

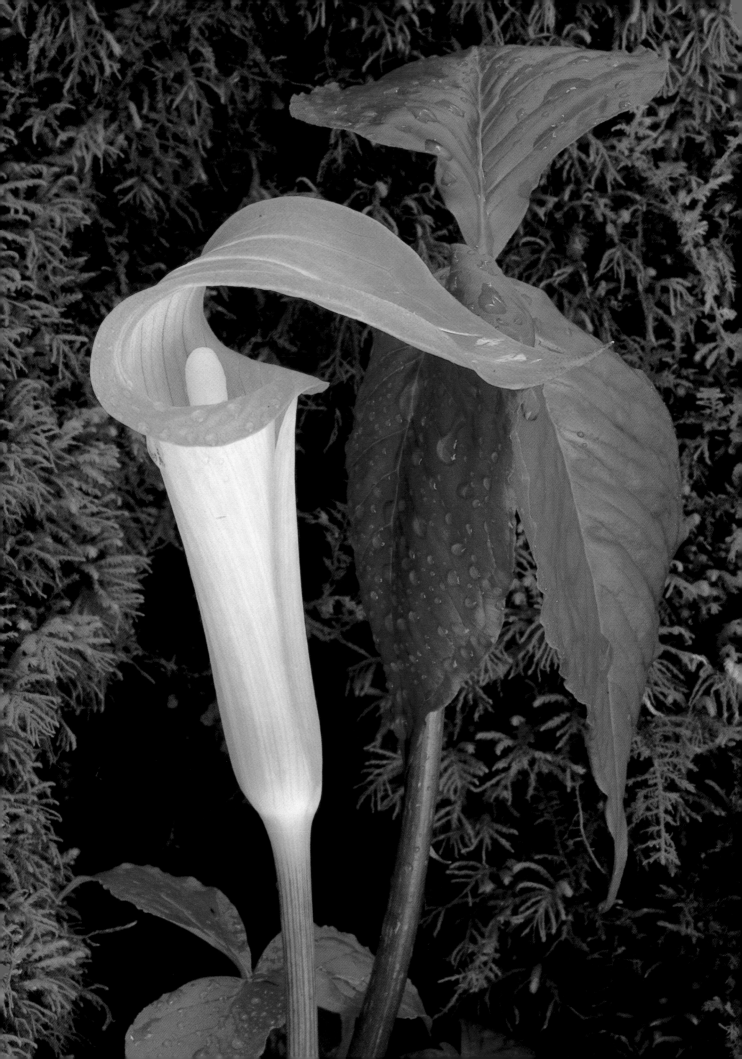

In the photograph opposite, Art Gingert demonstrates how a reflector in the field can be used to elevate the middle tone areas as well as open up shadows in a Northern Jack-in-the-Pulpit setting shortly after a morning rain. Backlighting is another example that is particulary effective when the subject is translucent as in the shot of a Desert Palm shown here revealing details about the subject's internal structure; 50mm macro lens, Kodachrome 25, f/8 at $^1/_{15}$ second (photo: Joseph Meehan).

for example, then a flat white surface and the most efficient reflector of all is a mirror, which will deliver virtually all the light from the source. As efficiency increases, though, so does the hardness of the light as it becomes more concentrated because less and less is being diffused.

A very large light source is a form representative of a heavy overcast day, where the sun's light now has virtually no direction at all and seems to radiate evenly over the whole sky, covering the subject from all directions with the same light intensity providing shadow less illumination that significantly lowers the difference in f/stops between highlights and shadows and, consequently, the overall contrast of the subject. There is almost a blending of HMS transitional zones to the point where it is hard to distinguish one HMS area from another. As a result, everything seems to be in the mid-tone range with most of it, in the case of a particularly thick, overcast day, further concentrated in the middle of this area.

The problem with this kind of light is that it is so flat that all but the brightest colours become very dull and that little bit of shadow area so necessary for details in surface texture is absent, having been completely filled in by the unidirectional nature of the source. Usually, only subjects with very high reflectance such as jewelry or shiny metal tools in table top close-ups are well served by such light. It is possible to build in a degree of contrast by intensifying the shadow areas with the use of 'subtractive reflectors' or 'gobos' as they are more commonly known. These are nothing more than pieces of black material placed to the side of a subject to block both source and reflected light from falling in an area. It is sometimes possible to drop the light level by one-half to a full stop with a gobo and therefore change completely flat lighting to something with at

least a degree of contrast.

The key point about a true large light setting is that it has no direction and envelops the entire subject with virtually the same intensity from all sides. Such a source cannot be moved around to produce a direction in order to cast some shadows. In a studio, the easiest way to achieve this light is to build a circular diffusion screen that surrounds the subject. The light source can then be aimed at it (like the sun behind the overcast) to be first scattered as it passes through the high diffusion fabric and then reflected off the internal sides. This is the principle of a 'lighting tent,' in which a strong diffusion material such as white fabric or translucent paper like Velium used in drafting is arranged in a cone around the subject. A hole is cut in the tent just large enough for the lens of the camera and one or two light sources are aimed at the sides.

One specialised light form that uses the wraparound principle in another way is a ring light. The ring is a circular flash tube mounted on the threaded front of the lens, which fires a circle of light at the subject, keeping shadow areas to a minimum, to deliver a very even though intense direct light. The latest models of these come equipped with TTL metering and 'modeling lights'; that is, a tungsten light used for focusing and showing the user the approximate effect. They are particularly effective with flat subjects which do not have very shiny surface areas.

Guidelines for Selecting and Controlling Light Sources

It is always a good idea to analyze the physical nature of your subject in order to determine what kind of lighting would best serve its presentation. While much

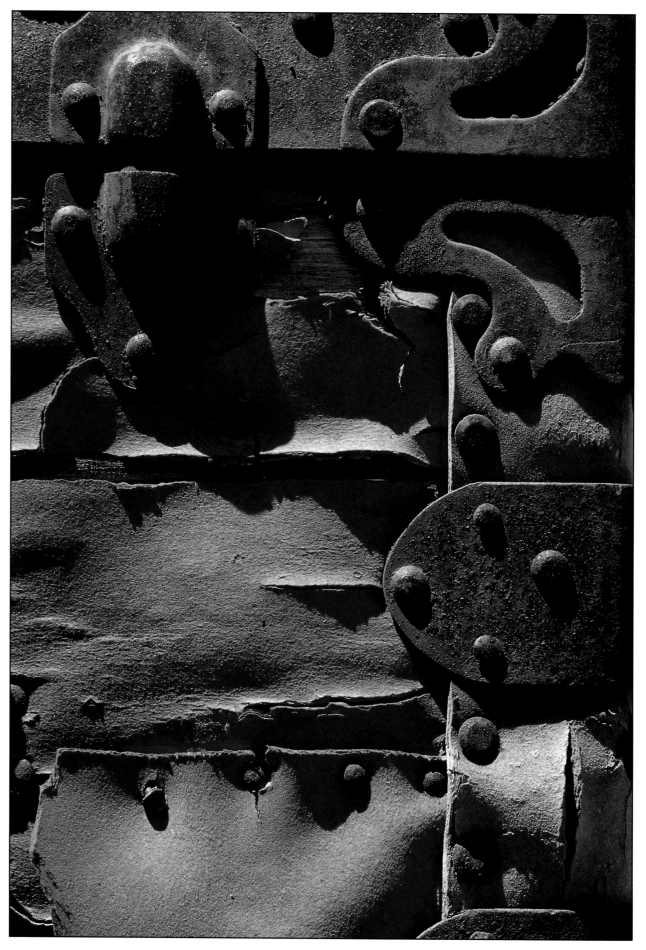

(b)

(c)

Besides the size of the light source affecting the way a subject will appear, its direction relative to the subject will also play a major role. This can be seen rather dramatically in the author's side lit shot of an old leather bound suitcase (a) that has been left in the heat and dry air of Death Valley, California; 105mm macro lens at f/11 at $^1/_{60}$ second, Agfachrome 50 and an 81A warming filter. A more subtle effect can be seen in (b) and (c) on a copy stand. In (b), the needlepoint work was first shot with both lights on at the usual 45° angle evenly illuminating the surface texture. In (c) however, the lights on one side were turned out and a white card was used to reflect back some of the illumination causing an over increase in the textural impression of the subject on the Fuji Tungsten film used (needlepoint by Anne Meehan, all photos by the author).

of this has to do with the photographer's personal interpretation of the subject, there are some things that should be considered. First, ask yourself, 'What am I taking a picture of?' The answer should not be limited to a self-evident statement like 'a rose blossom,' but rather a description of the photographic characteristics of the subject that have attracted your attention. A more useful answer would be: 'It is the beautiful and delicate pink colour of this rose in all its shades and the small shiny dewdrops on its soft petals.' Now you have something specific to think about in terms of light, and in this example, a medium to medium-soft light set at a slight angle would give the best rendering of the gradations of the pastel colour while picking up the bubble structure of the water droplets and preserving the soft texture of the petals.

Here, then, is a summary of guidelines that you can use. In general, soft colours and fine detail record best in medium to medium-soft light typical of hazy days or diffused flash, while highly reflective objects need a softer illumination as on an overcast day or in a lighting tent. Strong colours and non-shiny subjects do well in the brightest forms of medium light as on very bright hazy day of in direct sun where the deep, rich colour can be maximised. Distinctive surface texture works best with the same light set at a strong angle to the surface for producing those halo effects around specular highlights with a diffusion filter. Furthermore, whenever a diffusion filter is used in a high contrast setting, there is the good chance that it will lower the overall contrast by scattering enough light into the dark shadows.

The best choice for lowering the contrast of direct

small light sources is to use a diffusion screen over the subject outdoors with the sun, or indoors with studio lights. You should also consider using reflectors in the field or in the studio with a diffused or direct source to fill the shadows or to elevate the intensity of the mid-tones. Flat white reflectors or those with a silvery surface are the best choice here. When working with a small light source, white reflectors will basically just fill shadows; to effect the illumination level of the middle tones as well will almost always require a silver reflector.

In the case of back lighting where most of the subject is cast in its own shadow, the use of a reflector is highly recommended to bring the mid-tone/shadow areas up into the film's latitude. The surface choice (flat white or silver/white) is a personal one since a white surface will give a softer effect then a silver surface. Keep in mind that on foggy or misty days, colours are muted, which will not often give a good representation of pastels with strong colours such as with a bright red tulip, surviving better and standing out against generally subdued backgrounds. This is also the type of lighting in which to consider using CC filters to boost a single colour or a warming filter to deal with the excess of blue; but avoid soft filters here because of the already low contrast. The use of a warming filter in other lighting situations where there are no significant levels of blue is really a matter of personal choice based on its characteristic shift to a warmer rendering.

When shooting out-of-doors, the light form of the day determines, to a large degree, what subject matter to look for and what light modifiers to use. Windless, dew-laden spring and summer mornings are ideal for flowers and other delicate flora as well as for spider webs and insects which are still on their overnight perches waiting for the warmth of the sun. The best light here is slightly angular in direction and medium in form as the early sun rises through the mist or haze to give an ideal combination of subtle textures and a full display of colours from strong to pastel in various hues. Later, as the day's heat takes over in hazy conditions or through thin clouds, the light shifts to a higher angle and becomes a slightly harder medium source which is ideal for strong coloured subjects.

Bright sun anytime during the day gives the strongest textures and it is just a matter of finding an appropriate subject that is at the correct angle to the sun such as tree bark, weathered wood and paint peeling from a wall. This is also a good time to shoot up through subjects against clear blue skies as with broad leaf plants, to disclose their translucent structures. Remember, just the slightest miscalculation in exposure will wash out pastel or other weak-coloured subjects in bright sun or hard studio light and in general, a hard light is not as pleasing since the main characteristic of pastel colours is their subtle

hues. It is good practice to select an angle relative to the subject that limits the amount of pure shadow areas so common in bright sun, and concentrate on the strongly rendered mid-tones and highlights. This usually means setting the camera with the sun directly behind you for a front lighting effect. If the light is not straight on, then a reflector can raise the shadow values.

A full range of medium light illumination down to virtually shadowless light is available on any sunny day by just moving into the shade. The general guideline here is the further you move away from the source and 'deeper' into the shade, the softer the light. It is in these deep shade conditions as well as with fog and mist, that gobos can sometimes build up the contrast by introducing some definite shadow areas. Be very careful to avoid 'hot spots' or areas of bright sun coming through the shade of tree branches, as they will exceed your film's latitude and appear as burned out areas in the picture. Using a diffusion filter to pick up a halo effect on hot spots can work to lower the hot spot effect somewhat but the best choice is to use a light diffuser panel or cloth above the subject. In deep shade situations where the light is already becoming flat, a diffuser is generally not a good choice for hot spots, nor is a diffusing filter, since both will further lower the contrast.

Using light modifiers in the field often requires on-the-spot solutions to problems in their placement. Propping diffusing screens overhead requires some sort of frame and consideration for the flutter caused by any wind. Most photographers hand hold the panel and trigger the camera by using its self-timer, by a longer cable release or a remote electronic device. Some photographers use diffusers both for their light effect and also to help block the wind. One technique is to set the camera on self-timer and then hold the diffuser in place adding your body as a further wind block. Often, small white cards can be positioned near ground subjects such as mushrooms to add just a bit of needed fill the shadows.

Remember, too, that all of the principles of light modification that apply to studio light sources apply to outdoor lighting as well and vice versa; since, when you think about it, the sources of all light in both locations begin as small and directional sources.

Taken with a 55mm Nikkor lens and backlit with flash from behind the leaf, photographer George Rhodes created this graphic study.

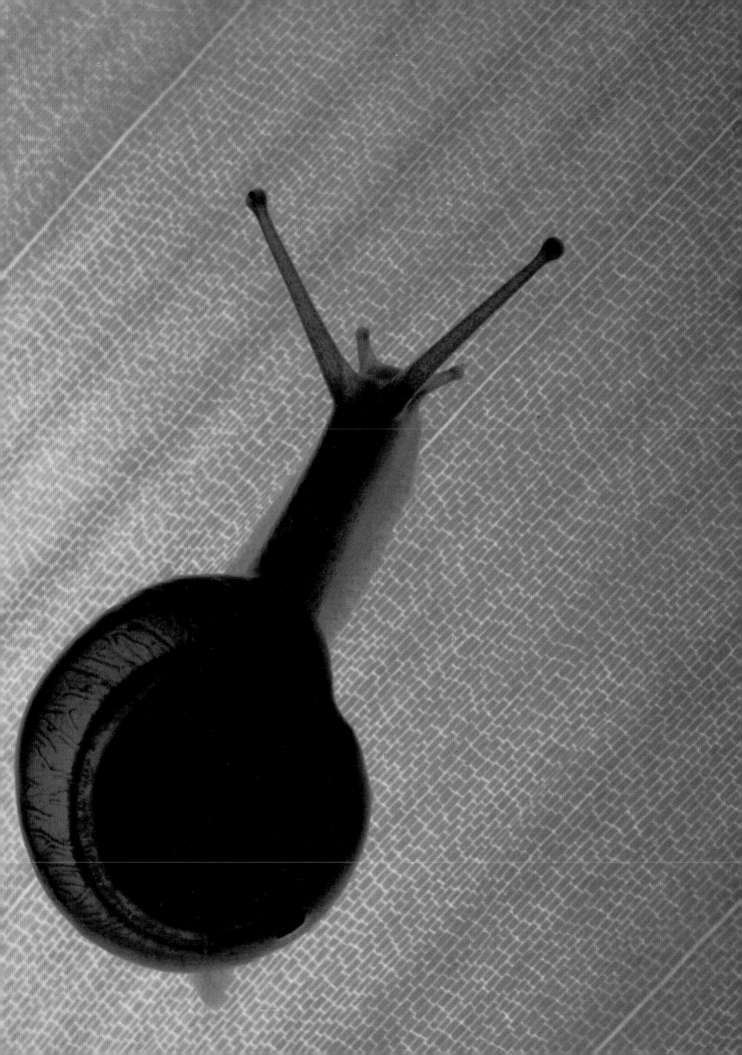

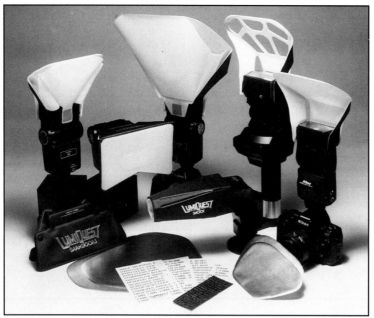

(a)

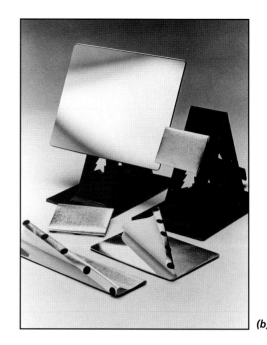

(b)

Setting up a Table Top Close-Up Studio

As was noted in the first chapter, the hallmark of table top close-up photography is control. Unlike the field photographer, who must wait for the 'right light' or modify what is there, a photographer working indoors with a small table top studio can simulate the three basic forms of small, medium and large light sources plus some that are not readily available in the out-of-doors such as placing a light under or shining it through the subject. All three light forms, small, medium and large, can be produced in a table top studio using either a small portable flash or tungsten light and light modifiers. The advantage of flash is that it delivers more power without any of the heat of a comparable hot light, and has a very short duration thus mitigating problems with subject and camera movement. The major disadvantage of using small portable flash is, of course, not being able to see the effects of the light as can be done with a continuous light source.

The guiding principle in tabletop close-up lighting is to take advantage of experiences with natural light and try to mimic the best of what has been seen. That means being able to arrange the light at various positions relative to the subject while using different diffusion/reflection materials. Here is a rundown of the choices.

Virtually any on-camera flash with a minimum guide number of 32 (in feet) based on an ISO 100 film can be used to shoot at aperture settings of f/11-22 with ISO 25-100 film in a table top work. The f/stop to be used at any distance can be found by dividing the guide number by the flash to subject distance. Thus, a flash with a GN of 32 fired at 2 feet would yield a shooting aperture of f/16. The easiest portable flash to use in terms of exposure, is one that operates according to a TTL dedicated system. The TTL

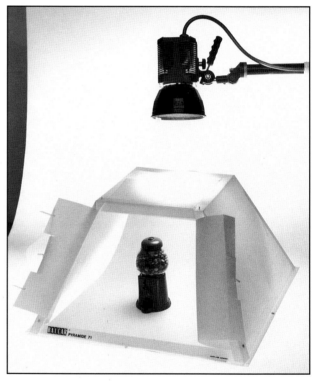

(c)

approach may not, however, allow an easy way of bracketing for different exposure effects. The second best choice is an automatic flash with detachable sensor. In this design, the flash controls the amount of light through its own sensor, which measures its reflected light off the subject and shuts the unit down when the correct amount is reached. The preferred model to use is one in which the sensor can be detached from the flash and left on the camera, allowing the flash itself to be placed behind a diffuser or inside the other types of modifiers. Again, there may be a problem with bracketing. Some automatic units do not work accurately at close distances so

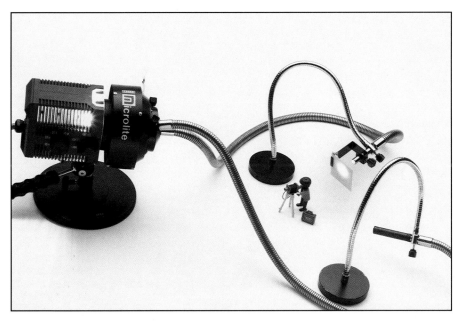

(d)

Some of the other useful lighting accessories that can be used in a typical table top studio include (a) a wide variety of small flash light modifiers from reflector cards to mini-soft boxes or (b) individual mini-reflector panels that can be placed on the table top (photos courtesy of Lumiquest); A special type of highly controlled light source can be obtained using flash transmitted by fibre optic flexible arms which can hold various filter and light modifying heads as shown here (d) with the Balcar Microlite which fits on any Balcar head or Monobloc or the Novoflex Macrolight Plus (f) that is designed around the use of any small flash unit. There are also commercially available light tents (c) which are particularly appropriate for highly reflective objects (all three photos courtesy of Calumet Professional Imaging). A light tent or diffusion screen can be made from diffusion material (e) (photo courtesy of Porter's Camera Store).

(e)

(f)

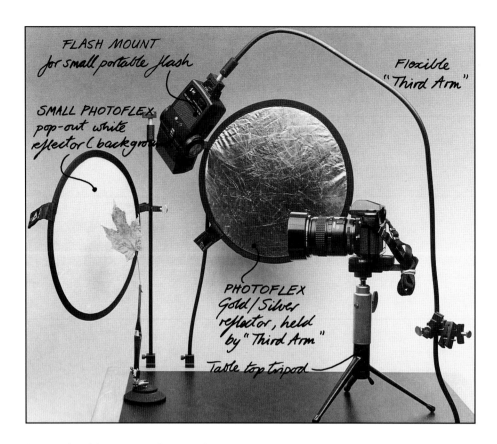

FLASH MOUNT
for small portable flash

SMALL PHOTOFLEX
pop-out white
reflector (backgro

Flexible
"Third Arm"

PHOTOFLEX
Gold / Silver
reflector, held
by "Third Arm"

Table top tripod

Working in the studio means being able to control, very precisely, the size, intensity and direction of the light used to take a close-up photograph. One of the most convenient ways of doing this is to set up a table top studio like the author's shown here which is equipped with the following very helpful items: Flexible 'third arms' (available from Sailwind/Camera World) that can be bent into any position and have attachments that allow the mounting of small flash units or reflectors. Shown also, are small Photoflex reflectors that work extremely well in a small set up like this (as well as in the field) as either reflectors or backgrounds in white (shown) or black. Note also, the table top Lietz tripod, which is much easier to position than a full-sized tripod set off to the side of the table (photo, Joseph Meehan).

longer focal lenses may have to be used or the unit switched to manual. One advantage of some of these units is that in a manual mode, the total light output can be adjusted through half, quarter and eighth power settings, making it easier to produce fill-in flash levels one-half stop and two stops below the ambient light. So as with a reflector, the photographer can control the contrast range of the scene by how much the shadow fill. The last choice is a flash that can be used in a manual mode with the amount of exposure checked with a flash meter.

There are a few important flash accessories that should also be part of any table top close-up studio. They are an extension cord connecting the off camera flash to the hot shoe or to the PC flash terminal of the camera; and a small light stand or inexpensive mini-tripod to hold the flash along with an adapter that allows it to be attached to the stand; and a fairly bright household light to work by while setting up the shot, and to make the final focus determination while checking depth of field.

Tungsten lights are available from a number of manufacturers in various sizes. A 250 watt 3200° Kelvin bulb in a suitable reflector, or better still, a quartz-halogen light of the same rating are two possibilities. The quartz light is a better choice because it maintains a consistent colour temperature throughout its much longer life. As tungsten bulbs burn, they build up deposits on the walls of the bulb that change the Kelvin temperature. On the plus side, tungsten bulbs are much less expensive than quartz. Both of these types of 'hot' lights come in a variety of

holders and reflectors, the most useful of which are 'barn doors,' which permit the photographer to restrict the main direction of the light and control spill.

There are many commercially available light modifiers for small flash and a few for tungsten light sources, plus a number of options for making your own. As would be expected, virtually all of the commercially available light modifiers are designed to modify the small harsh light of an on-camera flash to something in the more desirable medium sized light form. This is accomplished by either fitting the flash with a small light box or bouncing the light off a white surface directed at the subject by using any of the many light modifiers illustrated in this chapter. Most of these devices will not work well with tungsten lights because the heat they generate which runs the risk of melting the plastic materials. A better approach with tungsten is to direct it (from a safe distance) at a white reflector which will give a wide field of medium to medium-soft reflected light.

A third choice, which will work with either flash or tungsten, is to direct the light through a diffusing material held a few inches in front of the source. The density of the material will determine the degree of diffusion of the light and its intensity. In general, this will provide a slightly harder medium light than that reflected off a white board. Diffusing material can also be placed over the bounce reflector cards used with flash, enclosing the head to further soften the light in what amounts to a mini-softbox. One specialised version of this type of enclosed light modifier is the 'snoot,' which is a tube-like attachment useful for a

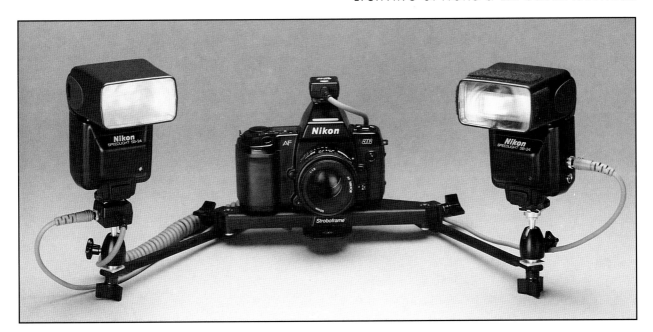

more directed and narrow light beam making a smaller, harsher light source.

Producing harder light effects typical of small light sources is simply a matter of using the flash or tungsten source alone, aimed directly at the subject. It is worth recalling that the categorizing of a light source's size is always relative to the subject's size. Therefore, moving in close to the subject means that the relative size of the source becomes bigger and the potential for pure shadow areas decreases. Finally, any of the modifiers mentioned or either light source alone can be equipped with coloured gels for added effects.

To achieve a true soft, shadow less light requires building a light modifier that will completely surround a subject. This is 'tent lighting,' which is based on the use of a translucent cone set over the subject into which one or two lights (flash or tungsten) are directed. Some models also come in the shape of a pyramid, but all work on the same principle of completely surrounding the highly reflective subject with soft even light.

Small reflectors and reflecting panels are also important modifiers for the table top studio. The biggest problem with reflectors in a table top close-up studio, as in the field, is finding ways to position them. Small clamp holders found in hobby shops and specialty tool stores, as well as photo stores, have adjustable arms that can be used to hold a reflector (and small subjects as well) exactly where needed. One simple but ingenious system by Lumiquest consists of folded, free-standing miniature reflectors that can be placed on any flat surface, which is especially effective for low-to-the-ground subjects.

One of the most unusual light sources is the fiber optic tube which takes light from a flash source and passes it down a flexible fiber tube for a very specific placement of the light. These units offer options such

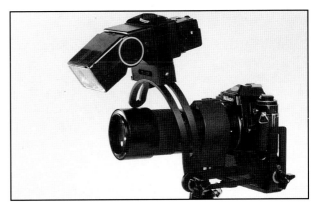

Working with flash outside usually means having to mount the flash on some sort of bracket to control the direction and make it easier to deal with under field conditions. The LP Macro Bracket from The Saunders Group is a proven design that allows the flash to be positioned on top or to the side of the lens while that company's Lepp II Dual Flash Macro Bracket provides for two flash units to be mounted in various positions.

Guide for Calculating Multiple Exposures and Ratios of Exposure

Number of exposures per frame	Exposure decrease factor for each shot
1	indicated exposure
2	-1 stop
3	-1$\frac{1}{2}$ stops
4	-2 stops
5, 6	-2$\frac{1}{2}$ stops
7	-2$\frac{2}{3}$ stops
8	-3 stops
12	-3$\frac{1}{2}$ stops
16	-4 stops

as diffusion and neutral density filters as well as focusing heads and gels to change the form, intensity and colour of the source. Fibre optic setups like these are particularly effective with very small objects measuring just a few inches and are capable of producing very intricate lighting arrangements. Also becoming popular are various 'light painting' tools, which are designed to allow the photographer to use a very specific pattern of light from a tool to produce accents, fills, halos and other refinements in the subject during a long exposure, and after the general exposure from a main light source. Most of the commercial light painting systems are designed for full-sized subjects in studios and are therefore too big for most close-up work. Some photographers, however, have used various small light sources to achieve similar effects, such as a fiber optic tool (or an ordinary pencil flashlight) used to burn areas of a print in black and white printing.

Determining Correct Exposure

Determining the correct exposure in close-up work, as in all forms of photography, is a matter of first understanding something about the qualities of light, subject illumination and film latitude and then relating that to how a camera meter works during the calculation of an exposure. It is for that reason that the subject of measuring correct exposure was saved for last in this book. Correct exposure for any subject is the combination of shutter speed and f/stops that places the highlights, mid-tones and shadows in their proper relationship to one another within the latitude of the film. This assumes that the type of lighting has produced a range of reflectance in which these areas can all fit within the film's ability to record this information. If not, then we have the choices already covered, namely the use of some light modifier to enlarge the source, or the use of a reflector (or fill-in flash) to raise the shadow and/or mid-tone values, or some combination thereof. How then do we determine which shutter speed and f/stop setting to use with each film speed?

Shutter speeds, aperture settings and film speeds are all based on numerical systems that indicate a uniform change. This is easy to see if we look at the standardised shutter speeds that are used on modern 35mm SLR cameras as shown in figure 2. Changing to the next faster shutter speed, as in $1/125$ second to $1/250$ second cuts down the light by one half. Slowing down the shutter speed one step as in $1/60$ second to $1/30$ second, doubles the amount of light reading the film. If we look at the f/stop scale, the same 'halving' and 'doubling' is also working, even though the numbers do not seem to indicate this. Nevertheless, whenever the camera is stopped down by one full stop, as in going from f/5.6 to f/8, there is a halving of the amount of light reaching the film just as would

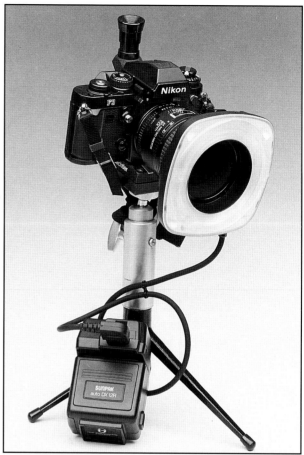

(a)

occur when shutter speed increases one step. Opening up one stop, as in going from f/8 to f/5.6, doubles the light just as slowing down the shutter speed setting by one step would do.

As a result of this uniform relationship between shutter speeds and f/stops, a photographer can change the amount of light striking the subject to the exact same degree by speeding up or slowing down the shutter speed or by stopping down or opening up the lens. Each full f/stop or shutter speed step will change the amount of light in the exact same way; that is, by either halving or doubling the light. So we can speak of 'stops of light' as a uniform amount of change produced by either f/stops or shutter speed changes. The only difference will be what effect the change will have on depth of field in the case of f/stop changes and the recording of subject movement and/or camera shake in the case of shutter speed change.

Figure 2 also lists film speed which is based on these same uniform changes. Therefore, doubling or halving the ISO rating indicates that a film is one stop different in sensitivity to light. For example, an ISO 25 film is one stop less sensitive to light then an ISO 50 film, while an ISO 100 film is one stop more sensitive than an ISO 50 film and two stops more sensitive than an ISO 25 film. Consequently, we can say that doubling the film speed indicates an increased

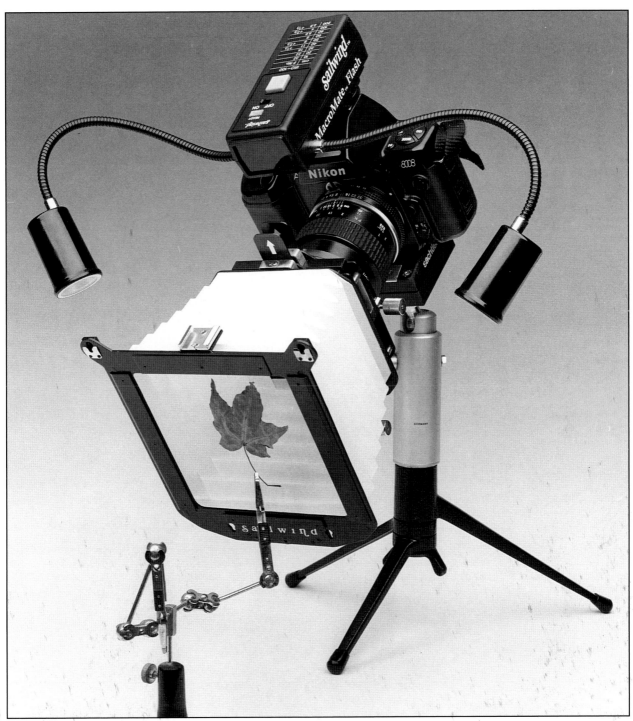

(b)

A very even illumination, especially for subjects held very close to the lens, is possible with a ring light as shown here (a) by Sunpack which is offered with various TTL modules for popular SLR cameras. This light source is mounted directly to the front of the lens' filter thread. Another even type of light but one closer to the effect of a table top tent is easy to achieve in the field or studio with smaller subjects by using a Sailwind/Camera World 'MacroMate' (b). The subject is placed up just inside the translucent hood and then flash from the adjustable mini-heads are fired through the hood. The light sources can also be used without the hood for direct lighting of a subject (both photos by Joseph Meehan).

sensitivity to light equivalent to one stop while halving the ISO rating results in a film that is one stop less sensitive to light.

From an earlier discussion on film latitude we established that film will only record a certain range of brightness which can be expressed in stops. For example, in the case of a typical transparency film, this is about three stops between the darkest shadows with details and the brightest highlights with details. So when we say a film has a 3 stop latitude range, that is what we mean; it has a range of three stops in which we can put visual information on that film.

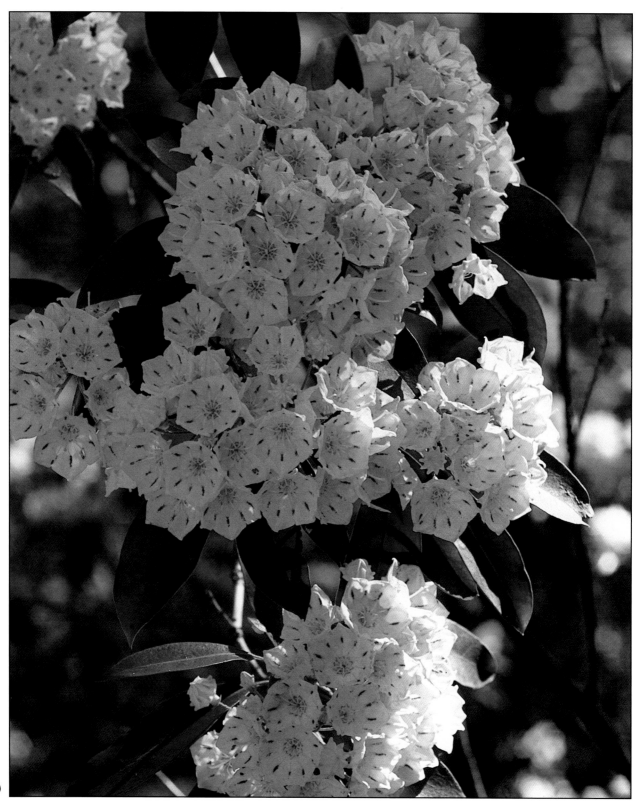

(a)

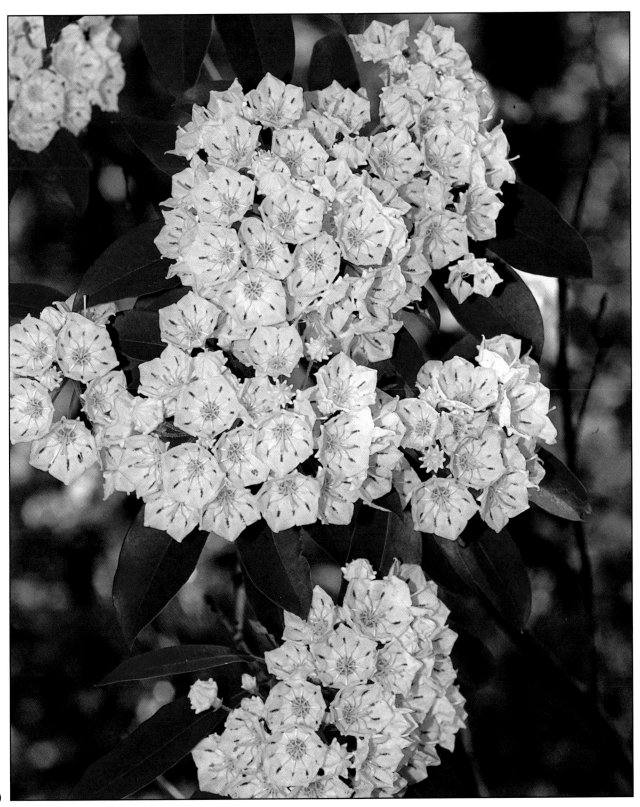

(b)

Flash can also serve very effectively to fill-in shadow areas or raise the value of the middle tones. In (a) and (b) Art Gingert demonstrates this alternate role for a small portable flash in the field. Normally, a portable flash used like this is set at an f/stop value between one and two stops below that of the ambient main light. This is most easily obtained by setting the flash in its Auto Mode at the f/stop below the camera's f/stop setting for the ambient light. Many TTL units also have a special 'fill-flash' mode which can be used in close-up applications.

Any flash can also be used in manual mode where the flash to subject distance determines the f/stop that can be used for the ambient light setting.

When a typical SLR's built-in reflected light meter is turned on, it picks up the entire brightness range and calculates an average reading for the exposure. The assumption in the design of the meter is that the scene being metered is an average one containing areas of highlights, mid-tones and shadows. Furthermore, an exposure based on a halfway point between the high/low areas of illumination in a scene (that is, the average illumination of the scene) will place all these areas properly. If, however, the meter were pointed at a white wall or a black wall, the meter would deliver a different set of recommended exposures for each subject but with the same result, a middle gray wall; because meters are calibrated to provide exposures that will produce an average of whatever they see. The meter would calculate readings that would cause the white wall to be underexposed and another set of readings that would cause the black wall to be overexposed, producing, in both cases, the gray results. Obviously, if the meter were then shown a middle gray wall, the set of f/stop and shutter speed exposure values it indicated for that subject would yield a correct exposure to produce a middle gray wall.

From this discussion then, two points become obvious; that the meter is programmed to compute an average of what it sees and, therefore, to get a correct reading, it must be shown those parts of a scene that when averaged will place the highlights, mid-tones and shadows appropriately. This is true of all the variations of camera meters that are available today; the only differences are in how they may divide up the scene and measure it. For example, some may be more center weighted than others, or have patterns that give more emphasis to various parts of the measuring grid. But all, sooner or later, take the measurements of high and low values within their areas of the grid or across the whole scene and average them to get the set of f/stop and shutter speed combination for the exposure.

The one exception, of sorts, is a spot meter, where the measurement is limited to a 1-3° area so that there is no real averaging in the limited portion; just the measurement of that small spot. Moreover, this meter is really intended to measure specific areas of uniform reflectance, leaving it up to the photographer to use this information to then reach a decision about the correct exposure. Typically, this means measuring the important highlight and shadow areas in which details are desired, then selecting an exposure halfway between. Once that figure is determined, the areas you want to show in the final image as middle tone areas are checked to see if, in fact, they fall into this exposure range.

The second critical point concerning exposure is what to show the meter. This is where the knowledge and experience of the photographer come in. There are several ways to use an SLR's TTL meter to determine exposure readings, and they are presented here for the reader's consideration. Each is based on principles already covered but each takes a different approach, favoring one set of conditions or another.

(1) Using a gray card.

In this approach, the meter is shown a standard middle gray card, which can be purchased at any photo store. It is calibrated for a reflectance exactly between white and black, which theoretically is the average reflectance of a scene of average brightness. Most of these cards measure about 8 x 10 inches, but because the typical close-up subject is so small, it is only necessary to carry around a cut-down version such as a 4 x 5 inch piece. Also, taping silver foil on the backside makes a very efficient reflector.

To use the card, just set up the shot, set the meter in the manual mode and place the card right in front of your subject and in the same light so that it fills the frame. Be sure to avoid any glare that may come off the surface of the card by just changing the angle slightly relative to the camera. One trick is to spray the card with a light coat of dulling spray or flat-finish clear spray. This not only mitigates the problem of glare but protects the surface of the card as well. Also, avoid casting a shadow over the card as it is held out in front of the subject. This form of metering will not give you any information about where your highlights and shadows will fall, but only that they will be recorded if they are within the film's latitude. This is the preferred method when working off a copy stand since, in virtually all cases, the even light with two lights set at 45° to the baseboard to minimise glare will deliver an average range of illumination. In addition, it is a good idea to calibrate the meter of a copy stand camera and to check the colour balance between the light source and film by shooting a standard test target consisting of a gray scale and colour patches as shown in the illustrations in this chapter (see also, Figure 1). Exposures should be made in increments of $1/3$ stops if possible and if not, in $1/2$ stops, and the camera's meter control scale adjusted according to the manufacturer's instructions.

(2) The palm of the hand method.

An alternative to the gray card approach is to use the palm of the hand as a standard; that is, the photographer places his or her palm in front of the subject in the same light, filling the viewfinder. The reflectance of the average palm, regardless of the person's racial type, is about one stop brighter then a gray card. Thus, the lens will have to be opened up one stop to compensate for this 'false' middle gray reading. As with the use of a gray card, it is advisable to run some tests to check the meter.

(3) The spot meter approach.

If the camera being used is equipped with a spot meter then a very accurate method of exposure is possible. A spot meter allows the photographer to check the individual values for the highlights, shadows and mid-tones. This permits a photographer to tell exactly which specific areas are going to be captured on film and what if any adjustments can be made as in a transparency film with a three stop range between highlights and shadows. As we have pointed out, the procedure with a spot meter is to read the high and low values that are to be recorded on film with details and expose the film exactly halfway between. Thus, the final readings used for the exposure should be the same readings one gets when pointing the spot meter at a true middle tone area in the scene. If the highlight to shadow range exceeds the film's three stop latitude then some thought should be given to using an appropriate light modifier. That is, a diffuser when there is a need to lower the value of the highlights (which also changes the light form) or a reflector to bring up the value of the shadows.

Here is an illustration of the spot-metering technique which will make clear the relationship in stops between the highlight, middle tone and shadow

The advantage of working with flash as the source of illumination is being able to put light where you want it and not having to worry about subject movement, as shown in Art Gingert's stop action shot of a Hummingbird in which the fast moving wings are frozen.

concept and the question of correct exposure for all metering methods. With a three stop latitude film, there can be no more then a $1^1/_2$ stop difference on either side of the exact middle mid-tone area. For example, in a close-up of a flower with leaves, the spot meter indicates an f/11 reading for the mid-tone area as represented by the medium green of the plant's large leaves in medium light. The shadow areas, made up of smaller leaves in the shadow of the larger leaves, measure f/8, which is -1 stop. The brightest highlights, as in the lightest areas of the yellow blossom in the sun, appear as f/22, or +2 stops brighter.

In this image, the shadows would fall within the $1^1/_2$ stop latitude but the blossom is outside the limit by $+^1/_2$ stop and would therefore appear washed out. There are two choices here. One is to adjust the exposure by stopping down $^1/_2$ stop. This would shift

all the HMS values down making all tones just slightly darker. The shadows would now fall outside of the film's latitude. More importantly, the highlight area of the blossom, which was the main subject of the picture, would now fall within the range of the film and be recorded with colour and details. The second choice is to use a diffuser between the light and the subject. This would lower the highlight-to-shadow value to within the film's latitude, but would also change the light from a small to a medium source, and thus change the effect of the original lighting. The exact effect of a reflector or diffuser can be measured with a spot meter.

(4) The middle tone method.

Another popular technique that is less dependent on standard references is based on measuring the middle tones in a scene with the camera's averaging mode. This is basically the same idea as the gray card approach, only here you are relying on the scene to supply the middle values. The trick is to be able to recognise just what is a middle tone area, and that is easy enough to do. Just spread out 20 or so of your pictures, and notice which areas tend to consistently make up the middle values in each scene under various lighting. A good number of examples can, of course, be gleaned from the pictures in this book. A photographer can also practice middle value

identification by walking around with a gray card and checking readings from it against choices made.

Once these reference points are part of the photographer's perception, the idea is to move the camera around in a scene in the same light as the subject is in and take an average TTL metering from this framing. Now, with these exposure values locked into the camera, return to the framing of the original shot and take the picture. The drawback of this approach is having to move the camera once it is set up, and also each time the light changes.

(5) Use of the camera's auto modes.

Today's very sophisticated 35mm SLR cameras come equipped with remarkably accurate meter systems in a wide variety of configurations. Many established professionals have switched over to these all-electronic marvels for close-up work, while others still maintain their tried and true exposure methods (as just covered) learned on manual models. The fact is, many of these newer meter systems are remarkably accurate and can be used with great success in the vast majority of close-up situations. The reader is, however, cautioned about the following realities. (1) These meters can still be 'fooled' when there is strong back lighting and the user is relying on a reading of the whole scene. Here, a decision has to be made as to what areas are most important because in

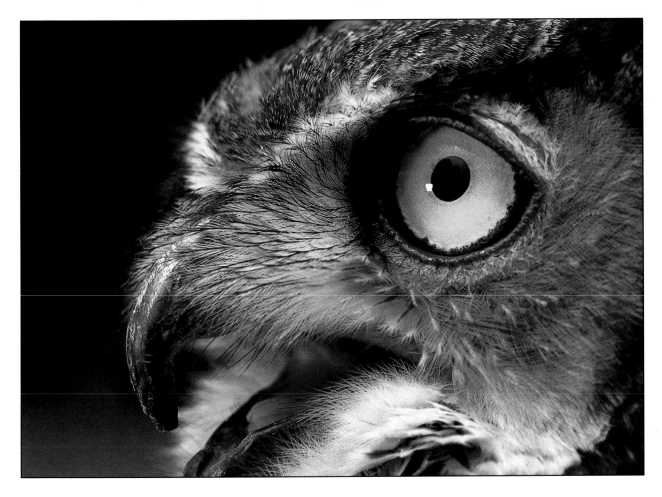

Whenever flash is used, special care must be taken with reflective surfaces. Such problems may not always be anticipated as happened here in Art Gingert's shot of a Great Horned Owl using a bounce card type reflector which has reflected in the bird's eyeball. Very large light sources such as overcast conditions as seen in the moderate close-ups of the young owls by Art Gingert typically have a wrap around, shadowless quality.

a typical back light situation the range of contrast is well beyond the latitude of the film. Thus, if the highlights are preserved with details, the mid-tones will likely fall into shadow areas and if the mid-tones are preserved, the highlights will be overexposed. To record the mid-tones correctly, use the gray card or palm approach. The spot method can also be used to measure the contrast in stops. (2) A situation dominated by specular highlights or a light source is another situation in which even the best metering systems are often fooled and alternative meter approaches must be used, in particular, the spot or middle tone approach. (3) Adjusting for bracketed exposures, the reasons for which will be covered in a moment, might be limited or not available at all in the

camera's auto mode setting. This requires something called 'auto bracketing' which is a separate feature from the typical auto-metering systems which is not available on all auto-exposure cameras.

Two final notes on exposure. First, with the exception of the last exposure method using auto modes, all the methods listed use the manual metering mode. Second, when working with transparency films, many photographers make it a common practice to bracket their exposures at either one-half and one-third stop under and overexposure as well as shooting at the indicated correct exposure. The validity of this practice is sometimes a point of disagreement between photographers. There are three good reasons to bracket. First, if the photographer has any doubts about the correct exposure, bracketing is a safeguard. Second, bracket if there is reason to wonder if a slight over or underexposure might benefit the final image. Most often, this means underexposing by one-third to one-half stop to pick up a greater degree of colour saturation. Finally, bracketing by one third of a stop under very frequently yields an 'in camera dupe' in the sense that this small change in exposure allows the photographer to see the effects of the exposure bracket while almost always getting a second image that has an acceptable exposure and is essentially a dupe of the original.

APPENDIX

Technical Information

The following technical information summarises and in some cases expands topics found in the text. If additional information is still required, the reader is referred to the books in the References.

Magnification and Magnification Ratios

To determine the size of the magnification ratio represented by a particular on-film image in relation to the actual subject simply divide the size of the image on film by the actual size of the subject. The 'size' of the subject is generally taken to be its long dimension as in height or length as opposed to width. Throughout this book figures for magnification ratios have been cited such as 1:2 or 1:10. In the X:Y ratio the first figure refers to the on-film subject and the second to the actual subject. Thus, a magnification ratio of 1:4 means that the actual size of the subject is four times larger than it appears on film whereas a 4:1 ratio would mean the reverse since the on-film image is now four times larger than the actual subject.

The 1:4 magnification ratio also means that the picture is being taken at $\frac{1}{4}$ life size magnification or a magnification of 0.25X which are alternate ways of referring to the degree of magnification that is involved.

Effect of Focal length on Magnification

To calculate the effect of changes in the focal length of a lens use the formula:

Magnification = Length of Extension/Focal Length

Effect of Lens Extension on Magnification

If you want to know the effect of various extension lengths as in extension tubes or bellows extensions on the magnification ratio of the subject, use the above formula cited for calculating the effect of focal length on magnification.

Changes in Exposure as Magnification Changes

Refer to the following formula if you are unable to use a TTL meter and need to calculate exposure as the magnification changes:

$$\text{Exposure Factor} = (M + 1)^2$$

Where: M= magnification (image size divided by object size).

Once you have obtained a value for the Exposure Value, for example 2.0, then increase the exposure by that figure which would be one stop in this example. This formula holds for symmetrical lenses which includes most normal and telephoto lenses that are commonly used in close-up photography. It does not apply to non-symmetrical lenses which includes most of today's wide angle lenses with angles of view greater then 75 degrees and true telephoto lens formulas with angles of view less than 20°.

Changes in Depth of Field as a Function of Magnification

Use the following examples to approximate the amount of depth of field you will be working with at a specific magnification ratio (regardless of the focal length of your lens). The figures given are for f/11

The depth of field will double for every two stops that the aperture is closed down and will halve for every two stops the aperture is opened up. The figures given here are for sharpness levels in which the depth of field is based on a 0.06mm circle of confusion.

Magnification Ratio		Total Depth of Field at f/11
1:10	=	100mm
1:2	=	6mm
1:1	=	2mm
1:2	=	0.8mm

Inverse Square Law of Light

Changes in the amount of light reaching a subject is a function of the distance between the light source and the subject as stated by the Inverse Square Law: The intensity of a point source of light (such as an on-camera flash) falls off in an inversely proportional amount to the square of the distance to the light as represented by the following formula:

$$E = I/d^2$$

Where: E = the illuminance produced by a point source with intensity I at a distance d.

It is because of this law that you must be careful

when moving a small flash for a close-up subject and recalculating exposure. Thus, if a flash is set at two feet from the subject with a calculated exposure of f/8 and you want to produce two stops more light then the flash must be moved to a distance of one foot from the subject which is one half the original distance.

Calculating Exposure Increases for Filter Factors

Many close-up photographers use warming filters, weak Colour Compensating filters and/or a polarizer all of which typically require exposure adjustments of less then two stops. Here, then, are some of the most commonly used filter factors and the equivalent changes in the aperture setting that must be made when using such filters.

Filter Factor	Aperture Increase (in stops)
1X	no change
1.2X	$+^1/_4$
1.25X	$+^1/_3$
1.4X	$+^1/_2$
1.6X	$+^2/_3$
1.7X	$+^3/_4$
2X	$+1$
2.5X	$+1^1/_3$
2.8X	$+1^1/_2$

Film Reciprocity

All photographic films respond to light by following what is called the Reciprocity Law which states that exposure is a function of both the intensity of the light and the length of time that the light strikes the film. The formula for this is simply:

$$E = I \times T$$

Where: E = exposure, I = intensity and T = time

Photographers use this law every time they calculate the exposure for a particular subject when they set the aperture (which controls the intensity of the light) and the shutter speed (which controls the time value).

This law, however, only applies to a certain range of shutter speeds. Use an exposure that is outside this

range that is either too fast or too slow and the law will not apply resulting in either underexposure, a colour shift, a change in contrast or any combination thereof. For example, for years, most black and white films follow the Reciprocity Law between $^1/_4$ second to $^1/_{1000}$ second although newer films, in particular, the T-Max films by Kodak have a far greater range. In the case of colour films that have multiple layers of colour, the range may not be the same for each layer so that there may be a need to use a colour filter to correct for a particular colour shift.

Data related to the Reciprocity Law or Reciprocity Failure as it is commonly referred to, is available from the film manufacturer or in various texts that cover working with colour film. It is worth knowing the range of the films you work with and what to do when an usually a long exposure or one from an extremely short burst of light from a flash is beyond the range of the film.

In the case of a high speed flash, it is very difficult to adjust for the failure of the film since you may not know the duration of the flash. It is worth testing your flash under typical shooting conditions and noting if there is an exposure problem or a colour shift. Under exposures can be adjusted for by resetting the film's ISO setting whenever the flash is used or by bracketing. Colour shifts can be corrected by viewing a transparency through CC filters until the colour correction is found and then those filters are used when the picture is taken.

REFERENCE

Alfred A. Blaker, **Applied Depth of Field** (Focal Press:1985). This is an excellent and complete treatment of the concept of depth of field which is so important to close-up photographers. Of particular note is Chapter 7, "Depth of Field in Closeups and Photomacrography."

Photography Through the Microscope (Kodak Guide #P-2) and Copying and Duplicating in Black and White Photography (Kodak Guide #M-1) are two through treatments of specialised areas of close-up photography which were not covered in this text.

The Kodak Professional Photoguide issued by the Professional Markets Division of Eastman Kodak is an excellent resource book for all photographers with sections on close-up photography. Specifically, in the last edition under, "Close Up Exposure Dial and Formulas" there is a very handy moving chart that integrates all the key variables in close-up photography including magnification, focal length effects, subject dimensions and corrected exposures. There are also all the major formulas relating to close-up photography for all film formats.
This guide is presently undergoing revision but the last edition is still a very useful reference since the technical information on close-up photography does not change.

The Focal Plane Encyclopedia, 3rd edition, edited by Leslie Stroebel and Richard Zakia (Focal Press:1993) is the latest version of this standard reference work and contains thorough explanations and formulas for all of the concepts, terms etc., used in this text.

Joseph Meehan, **A Photographers Guide to Using Filters** (Amphoto:1992) is a more complete treatment of the use of filters in photography than the introductory information found in this text. In particular, the explanations of the way Colour Compensating (CC) filters and various filter combinations can be used should be of interest to close-up photographers.

INDEX

NOTES